Maryland in Black and White

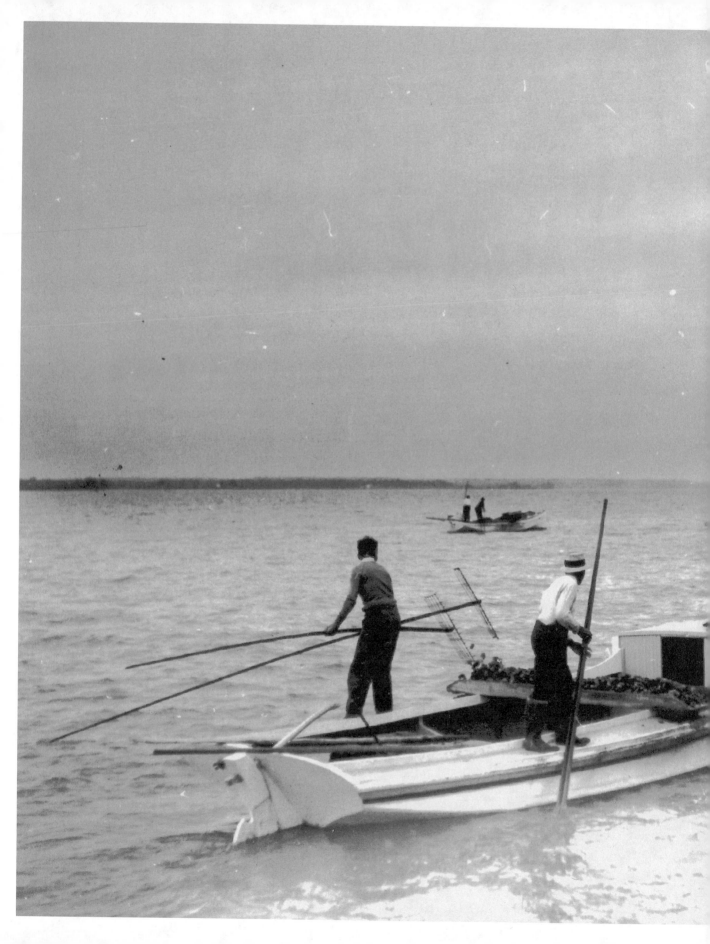

Maryland in

Documentary Photography
from the Great Depression
and World War II

Black and White

Constance B. Schulz

Foreword by
Frederick N. Rasmussen

Johns Hopkins University Press, Baltimore

© 2013 Johns Hopkins University Press
All rights reserved. Published 2013
Printed in the United States of America on acid-free paper
9 8 7 6 5 4 3 2 1

Johns Hopkins University Press
2715 North Charles Street
Baltimore, Maryland 21218-4363
www.press.jhu.edu

Library of Congress Cataloging-in-Publication Data

Schulz, Constance B.
 Maryland in black and white : documentary photography from
the Great Depression and World War II / Constance B. Schulz ;
foreword by Frederick N. Rasmussen.
 pages cm
 Includes bibliographical references and index.
 ISBN 978-1-4214-1085-2 (hardcover : acid-free paper) —
ISBN 1-4214-1085-0 (hardcover : acid-free paper) — ISBN 978-
1-4214-1120-0 (electronic) — ISBN 1-4214-1120-2 (electronic)
 1. Maryland—History—20th century—Pictorial works.
2. Maryland—Social conditions—20th century—Pictorial works.
3. Depressions—1929—Maryland—Pictorial works.
4. World War, 1939–1945—Maryland—Pictorial works.
5. Documentary photography—Maryland. 6. Black-and-white
photography—Maryland. 7. United States. Farm Security
Administration. 8. United States. Office of War Information.
I. United States. Farm Security Administration.
II. United States. Office of War Information. III. Title.
 F182.S38 2013
 975.2'043—dc23 2013004816

A catalog record for this book is available from the British Library.

Special discounts are available for bulk purchases of this book.
For more information, please contact Special Sales at
410-516-6936 or specialsales@press.jhu.edu.

Johns Hopkins University Press uses environmentally friendly
book materials, including recycled text paper that is composed
of at least 30 percent post-consumer waste, whenever possible.

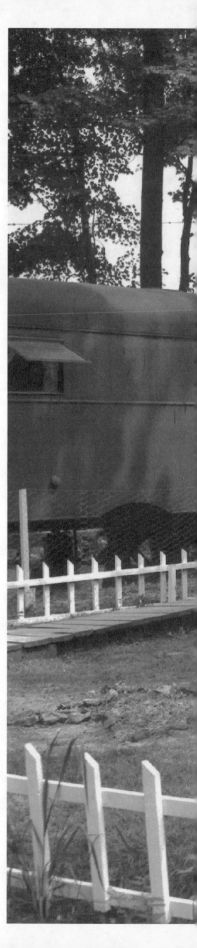

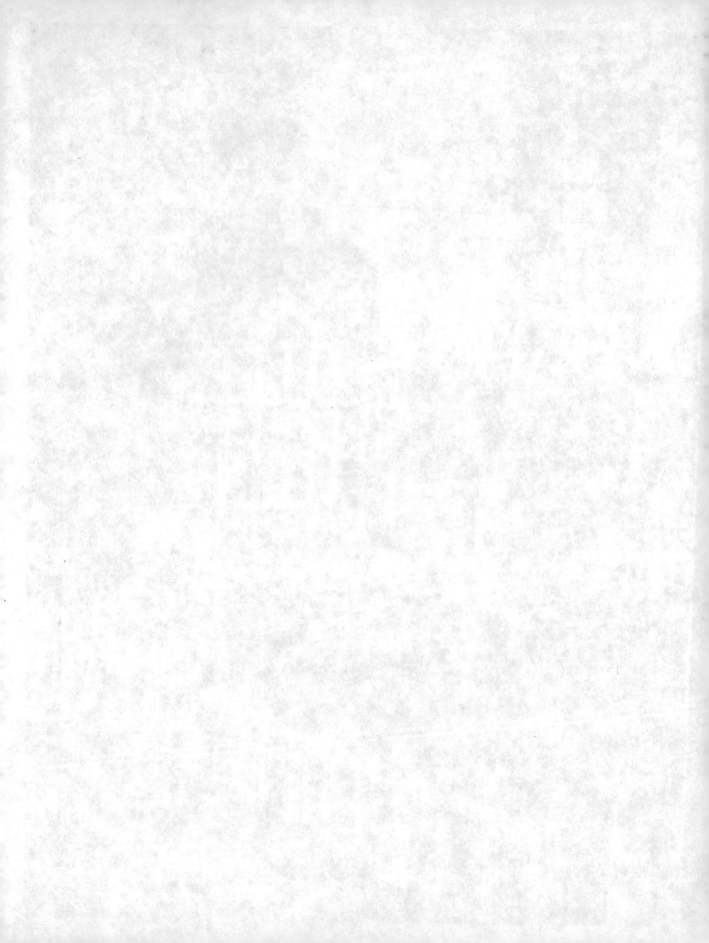

Contents

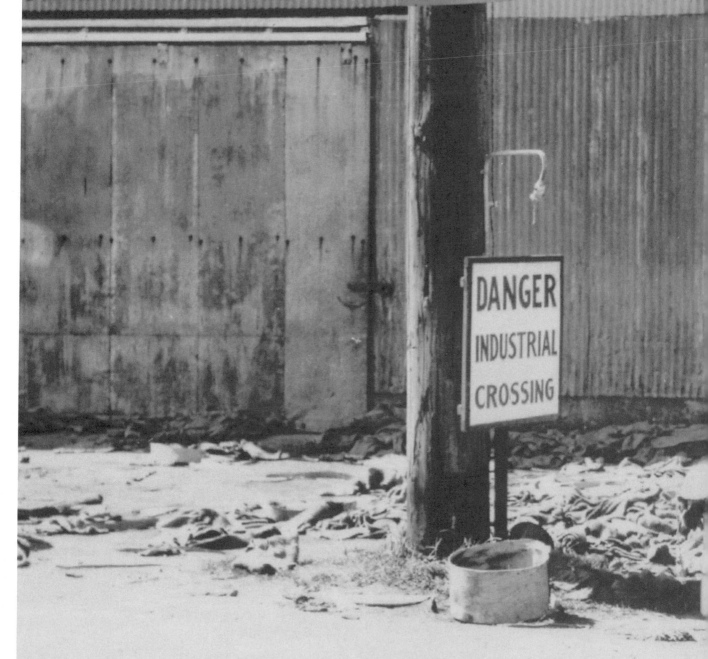

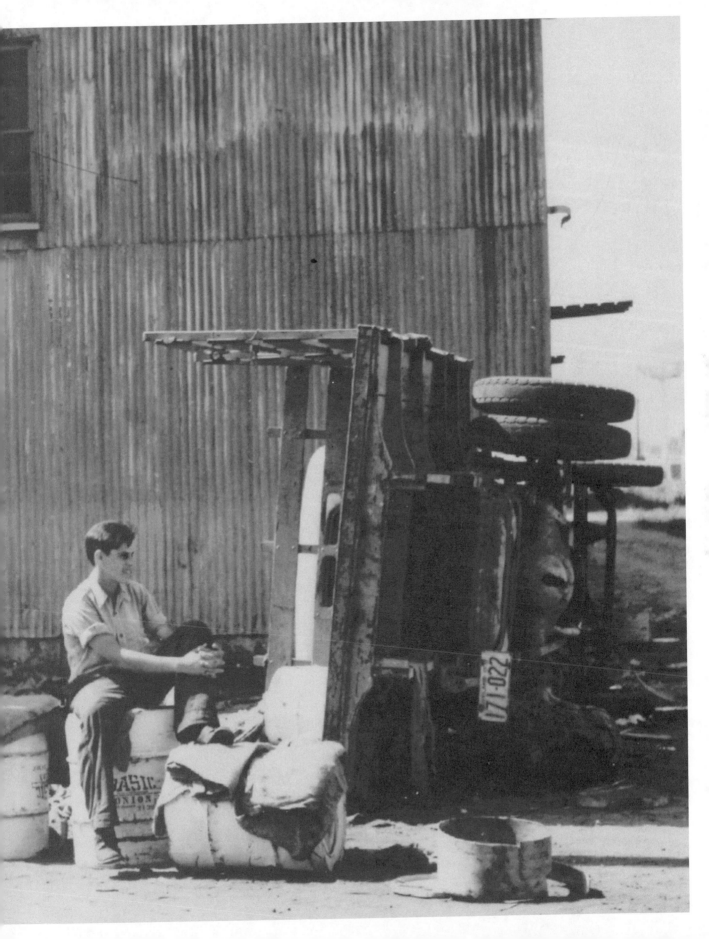

Foreword
By Frederick N. Rasmussen

In her latest book, *Maryland in Black and White: Documentary Photography from the Great Depression and World War II*, Constance B. Schulz presents more than a hundred choice images, re-focusing our attention on a momentous period in Maryland and American history: the Great Depression and World War II.

For the raw material of some four thousand photographs Schulz rightly credits Roy Emerson Stryker. Between 1935 and 1943, Stryker headed what was known as the "Historical Section," which formed a part of the Farm Security Administration and later part of the Domestic Services branch of the Office of War Information.

During those years, twenty-six photographers from the agency drove out on assignment across Maryland to record on film what life was like in the state, a place that was perhaps even more diverse in those years than it is now.

When I reflect on the grimness of the Depression and World War II, I naturally think in terms of the dramatic qualities of black and white photography. Among the images Schulz includes here, even a seemingly routine photo of a Hagerstown railroad station has a certain wonderful, almost Edward Hopperesque, quality to it.

Of the three best-known photographers whom we associate with Depression images—Dorothea Lange, Carl Mydans, and Walker Evans—only Mydans took photographs in Maryland for the Historical Section. Yet Lange and Evans influenced the work of countless other photographers working with Roy Stryker, some of them just starting out in their careers. Readers may be surprised to learn that such noted artists as Arthur Rothstein, Jack Delano, Marion Post Wolcott, and even Ben Shahn roamed the state, from tidewater marshes to western mountains.

Stryker's photographers apparently spent most of their time in rural Western Maryland and the Eastern Shore, observes Schulz. Images of farmers toiling in fields, performing backbreaking work with teams of horses, capture a truly rugged way of life. A Rothstein photo of an abandoned hotel and general store in Jennings, Garrett County, looks as though it were a still from *The Grapes of Wrath*. But life was tough all over. On Chesapeake Bay, white and black watermen turned in long days in almost all kinds of weather tonging for oysters

and crabbing. A striking worker in 1937 at the Phillips Packing Co. plant in Cambridge sits under a sign that says "We can't live on $9.80 a week. It is 40 cents too less."

Photographs of Baltimore, which for reasons Schulz explains only got assigned starting in 1938, include a Sheldon Dick image of a woman completing the weekly ritual of scrubbing her marble steps—once so emblematic of Baltimore—as well as prints from the "Negro District" and of slum children. Jack Vachon's photograph of the "Municipal Baths," which were located in a rather battered two-story clapboard house, looks like something out of Dickensian London.

Delano's images of a Route 1 diner advertising platters for 25 cents and hot dogs for 5 cents speaks to Depression-era prices that even at that were too high for many. A photograph of "colored tourist cabins" near Waterloo reminds us of the racism prevailing at the time.

Schulz's selection of Depression-era photos of simple people display a wonderful portraiture. These are the faces of the stressed—many of them impoverished rural poor and African-Americans—who no doubt were wondering where and when it would all end. For all of their sadness, they have a nobility about them and an American determination to see it through.

The subsequent coming of World War II put an end to the Depression as Baltimore's factories, harbor, and railroad yards once again throbbed with activity. The dramatic wartime scenes of Bethlehem Steel's blast furnaces and shipyards persuasively illustrate Baltimore's role in the "Arsenal of Democracy." At its peak in late 1943, the Bethlehem-Fairfield Shipyards employed 46,700 workers, including 6,000 African-Americans, who worked there around the clock, twenty-four hours a day, seven days a week. By war's end, the shipyard had been built and had launched more than five hundred vessels—more than any other American shipyard.

And in 1945, with victory and considerable pent-up consumer demand, the Maryland of the previous fifteen or twenty years would leave behind little more than photographic memories.

Acknowledgments

This book has been years in the making, and I owe a considerable debt to many people who helped bring it to publication.

Dr. Raymond Smock first introduced me to the photographs of the Farm Security Administration at the Library of Congress nearly forty years ago when I was working with him to create *The American History Slide Collection* and *The History of Maryland Slide Collection*.

The wonderful staff at the library's Prints and Photographs Division, especially Beverly Brannon, have nurtured my interest and corrected my errors ever since. When I began work on FSA photographs of Maryland, the Library of Congress had not yet completed their digitization project giving researchers like me online access to the full collection, and Dr. Daniel Vivian, then a graduate student at the University of South Carolina, patiently went through the microfilm reels of the "lots" in which Maryland FSA images appeared, making a detailed list of all photographs and their captions, and suggesting images I should consider for inclusion.

Special thanks belong to Johns Hopkins University Press editor Dr. Robert J. Brugger, who believed in this book and kept it from getting lost in the shuffle.

Finally, *Maryland in Black and White* is for my three children, Elisa, Andrew, and Jessica, who grew up in Maryland and will recognize many of the places pictured here. The photographs illustrate that Maryland was and still is a good place to raise a family.

Maryland in Black and White

The Context

Our visual memories of the Great Depression are indelibly linked to the work of a small federal government agency that operated between 1935 and 1943 under the direction of a single man, Roy Emerson Stryker. That agency was known to its staff and friends as the "Historical Section," but it is better known today by the name of the first of the two larger agencies of which it was a part—the Farm Security Administration, or FSA. The Farm Security Administration actually began its existence as the Resettlement Administration in 1935 and was renamed when its functions, including those of the Historical Section, were transferred into the Department of Agriculture in 1937. In 1942 the Section briefly moved administratively into the Domestic Services Branch of the Office of War Information (OWI); hence the frequent identification of the file of photographs it produced as the "FSA/OWI" collection.[1]

Both the file and a large body of written records produced by Stryker and his staff are part of a collection that is now housed in the Library of Congress in Washington, D.C., available to the public through its Prints and Photographs Division. The collection contains 164,000 black and white negatives and 1,610 35 mm color transparencies taken by the photographers in the early 1940s, both of which are available online. In addition, 107,000 photographic prints from the FSA/OWI vertical files are available in filing cabinets in the Prints and Photographs Division reading room.[2]

Despite its small size, Maryland is disproportionately represented in the photographic files of the FSA/OWI. Twenty-six of the forty-four photographers whose work contributed to the files found themselves in the Old Line State at some point during the eight years in which the Historical Section operated. The nearly four thousand photographs they created range from views of the mountainous western reaches of Garrett County to the southern shores of the Chesapeake Bay. Within those four thousand are images both stunning and mundane, depicting significant events as well as routine activities. Readers of this book who find a photograph they particularly like, or who are intrigued by the way in which a particular photographer approached Maryland places and people, can now go online to search for and study any of the images on their own (see www.loc.gov/pictures/collection/fsa/).

On one level, the images of Maryland in the FSA/OWI collection are a series of interesting pictures that jog our collective visual memory of what the state was like three quarters of a century ago. Indeed, for some viewers, the images too readily lend themselves to a selective nostalgia, to an uncritical enjoyment of their evocation of a simpler past: of a placid ferry trip across the Potomac River, or of a crowded room of soldiers and their girls dancing the jitterbug at a wartime senior prom in Greenbelt. But as with much historical evidence, the photographs provide a richer reward to those willing to look

beyond the surface. As those who lived through the times these photos document reach the end of their lives, we who remain behind no longer have access to their corrective memories. Hence, it is worth holding these photographs up to the light for closer scrutiny, placing them in the context of both the process of their creation and the goals of their creators.

There are three contexts for the photographs of Maryland that help readers to understand what was—and what was not—included within the frame of the camera's lens and the lab technician's prints. The first context is the *place* itself, the story of the state of Maryland during the years of the Great Depression and the Second World War. That story is a complex one, and its brief summary below is meant only to remind readers that there is more to remember about the people who lived in the state between 1930 and 1945 than the four thousand images, of which only about a hundred are reproduced here, capture on film.

The second context for the images is the *project*: the Historical Section of the Resettlement Administration and the Farm Security Administration, whose larger purposes shaped the circumstances in which the photographers were hired, the assignments they were given, and the selections made by others of which of their images to keep and which to discard. The photographs are a direct result of the particular goals that the federal government policy makers had in mind when they created the Resettlement Administration in the first place, and the reasons they wanted a file of photographs to support those goals. The photographs also reflect changes made over time to the goals of the larger agency, as well as the purpose and use of the photographic file. Understanding Roy Stryker's vision for and administration of the Historical Section helps to explain both the presence and the absence of certain images. Why, for instance, are there no images of Baltimore before 1938 when there are sixty images of a Southern Maryland FSA agent building a screen door? Does the focus on what, in retrospect, seems trivial while ignoring something as important as a major urban area in a time of crisis discredit the photographs as a reliable record of the past?

The individual stories of the *photographers* form the third context for the images. The photographic process may be rooted in the exact science of chemistry and physics, but photography itself is inherently an art as well as a craft. Film records, more or less faithfully, what the lens of the camera focuses on its emulsion-coated surface. But the choice of what the lens and film capture in the moment that the shutter is clicked is made by the photographer. All photographers bring to those choices their own history, their own passions about the nature of the world and its people, and their own ability to "see" telling details or provide a particular perspective. In the 1930s and the 1940s, most of the young photographers who worked in Maryland for the FSA were at the beginning of their long careers as professional photographers. Many

later became well known for their documentary photography and are now respected as significant artists. The context of their stories, though told briefly, is an important component for understanding and enjoying the photographs gathered together in this book.

The Place: Maryland, 1930–1945

Maryland has long been recognized as a microcosm of America in many ways: a middle ground where beach and mountain, north and south, urban and rural, black and white, farmer and businessman, and young and old have all met and carved out places for themselves, if not always peaceably. The period of time documented by the FSA/OWI photographs, brief though its eight years were, represents an important turning point in the state's story, one partially the result of accelerating forces already at work to be sure, but also marking new directions that have defined it in the decades since. The pace and nature of those changes varied from region to region. Yet even in those areas that seemed most resistant to change—the Chesapeake Bay where oyster tongers harvested their catch using methods unchanged for centuries or the mountains and streams of Garrett County where the seasons timelessly repeat themselves—the momentum toward a modern economy, influenced, if not dominated, by urban and national concerns, had an impact.[3]

The two great forces that brought about or accelerated these changes were the economic crisis of the Great Depression and the enormous mobilization and mobility of America's—and Maryland's—resources and people required by participation in the Second World War. It is with these two events that the photographs in this book are mostly concerned. Maryland had experienced a period of prosperity during the 1920s, although its rural farmers and watermen and its urban African-Americans and organized laborers had not shared in the economic growth enjoyed by Baltimore's manufacturing, trade, and transportation industries. That prosperity came to an end in the aftermath of the stock market crash in October of 1929.

The full effects of the crash and the depression that followed were felt more slowly in Maryland than in other areas of the country. Maryland's diversified industrial economy cushioned the impact of trade loss and consequent layoffs of workers. Because of conservative banking practices, relatively few Baltimore banks failed at first. Home ownership among white Baltimoreans was high, around 50 percent, and the practice of paying off mortgages in five years meant that many did not lose their houses to foreclosures. (Among African-Americans, the ownership rate was less than 20 percent, and many did lose their homes.) Yet despite optimistic predictions by the Baltimore Association of Commerce in 1930 that "industry as a whole was in good shape" in the city and state, unemployment rolls continued to grow.[4]

Women and African-Americans were the first to lose their jobs, but soon to follow were union workers, coal miners in the western part of the state, and salesmen in retail businesses that failed as consumers used up their savings and could no longer buy goods and services. Baltimore's unemployment rate stood at 19 percent in 1931. In the fall of 1931, Baltimore's second largest bank, the Baltimore Trust Company, closed its doors. The Central Trust Company of Frederick, the largest bank in its region, failed, taking with it eleven branches, the life savings of its investors, and a dozen other smaller banks in Western Maryland.[5] By the winter of 1933, unemployment was widespread: one Baltimore family in six was on welfare; 46 percent of the men in Somerset County were unemployed. The black community of Baltimore, where 18 percent of the city's population crowded into the oldest and most dilapidated of its housing, by 1934 suffered an unemployment rate of 50 percent.[6]

The human suffering behind these numbers is perhaps incalculable. In the cities, young couples postponed marriage, fewer babies were born, and some men deserted their families rather than stay to watch them starve, believing that without an employable man in the house their loved ones might receive more help. Children came to school without breakfast, or did not come to school at all because they had insufficient clothing or shoes.

In Maryland as in much of the nation, the traditional approach for dealing with unemployment and hunger relief was through local private charities, but the depression that began in 1929 generated need that far outweighed their combined resources. The relief expenditures of Baltimore's Family Welfare Association, the city's largest agency, illustrate the depth of the problem: $200,000 spent in 1930; $600,000 in 1931; $3,400,000 in 1932.[7] The situation in many of the counties outside Baltimore, where there were fewer or no private agencies, was even worse.

As the resources of private charitable organizations were exhausted, leaders of these groups called for government assistance. Democratic governor Albert C. Ritchie and Baltimore's newly elected Democratic mayor Howard Jackson responded, albeit cautiously. First local, then state government stepped in to help, lending money to the Citizens' Emergency Relief Committee. Although a moderate Democrat, Ritchie was opposed to federal interference in his state and resisted federal help offered by Republican president Herbert Hoover through the Reconstruction Finance Corporation until 1933.

In 1933 there was a new administration in Washington prepared to offer much more powerful assistance to the states to deal with their economic and human crises. President Franklin Delano Roosevelt initiated a series of programs known collectively as the "New Deal," designed to stimulate recovery of the economy and provide relief for the millions of Americans out of work and out of funds. Scholars have identified two distinctive New Deals. The first was conservative and cautious in its fundamental approaches but innovative

and experimental in its tactics, drawing on cooperation from business and labor through the National Recovery Administration (NRA) to get businesses back into production, initiating public works programs such as the Public Works Administration (PWA) and the Civil Works Administration (CWA) to put people back to work on large and small work relief public projects. The Civilian Conservation Corps (CCC) offered special relief for unemployed young men, organizing them in residential camps and putting them to work on outdoor projects, thus relieving their families of the obligation to feed and clothe them and providing the workers with a small paycheck to send home. The Agricultural Adjustment Act (AAA) attempted to stabilize farm prices, and the Emergency Bank Relief Act was designed to restore banks to solvency and reassure their depositors.

All of these programs of the first New Deal had an effect on Maryland. At its height, shortly before it was disbanded in the spring of 1934, the CWA employed 22,000 people, many from the relief rolls in Baltimore, putting them to work trapping rats or using picks and shovels in frozen earth to landscape public properties.[8] Baltimore mayor Jackson used the opportunity to apply for PWA funds to implement a recently adopted plan for city improvement. Between 1934 and 1937, Baltimore spent $100 million of PWA money, at its peak hiring 12,500 formerly unemployed workers. Parks, new viaducts and highways, buildings for Morgan College and the Walters Art Gallery, expanded water and sewage treatment facilities—all were the result of federal government recovery funding.[9]

The second New Deal began in 1935, when Roosevelt became disillusioned with the business leaders he had attempted to assist who had consistently opposed his attempts to help labor and consumers. Roosevelt and the Congress elected in 1934 created much more aggressive and radical programs to attack what he and his advisors considered the root causes of the Depression. The experimental but limited CWA was replaced by a much broader Works Progress Administration (WPA), which went beyond hiring laborers to work on restoring the nation's physical infrastructure to offering work for everyone who needed it. Artists and musicians painted murals and held public performances. Historians and writers conducted interviews with former slaves, copied historical records in county courthouses and church basements, and created a series of *Guides* for each of the states. To assist the poorest farmers whom the AAA had not reached, Roosevelt called "brains truster" Rexford Tugwell to Washington to create the Resettlement Administration. The National Labor Relations Act of 1935 assured labor of the right to organize collectively; the Social Security Act created a source of retirement income for older workers for whom company pension plans were non-existent, or were bankrupted by the stock market crash.

These "second New Deal" programs also had an impact on Maryland.

The programs of the WPA reached into every corner of the state. *Maryland, A Guide to the Old Line State,* published in 1940 as a WPA project, has been updated over the years and is still a useful compendium of information about the state and its history. In small-scale WPA work projects, communities all over Maryland installed basic sewer systems, created parks and playgrounds, paved streets, and bordered them with curbs and sidewalks.[10] Under the National Labor Relations Board (NLRB), laborers in Baltimore's clothing and steel industries, in Maryland's western mines, and in many other (but not all) industries made real gains in terms of recognition of their unions and collective bargaining.[11]

Maryland's four-term governor Ritchie, though a Democrat, stood fast to his principles of state sufficiency and opposed many of the New Deal programs. For his opposition he paid the price of losing the 1934 re-election campaign to his pro–New Deal Republican opponent, Harry Nice. In Baltimore, Mayor Jackson, consistently opposed to what he considered the radicalism of New Deal programs, successfully managed to seek out federal funding for civic construction and at the same time to resist federal relief efforts. One could argue that, in some ways, New Deal programs had an impact in Maryland in spite of the opposition of the state's political power structure.

At least part of that power structure's opposition to the New Deal, and its accusations of radicalism against New Deal programs, stemmed from fears that those programs, through their various efforts to empower African-American laborers and farmers, however halfhearted, threatened the long-standing post-reconstruction racial policies that relegated blacks to the bottom of the Maryland economic and social system. For African-Americans, the 1930s were even more devastating than for most Marylanders. Tension over rising unemployment in heavily black counties on the Eastern Shore and in Southern Maryland counties led to outbreaks of violence, and in 1931 and 1933, two highly publicized lynchings. It was no coincidence that Baltimore-born jazz singer Billie Holiday recorded the haunting lyrics of "Strange Fruit," a lament for black bodies swinging from trees.[12] Perhaps the power structure was right to fear the New Deal's insistence on change, for the African-American community did demand—and make—some gains. In Baltimore, Lillie Mae Carroll Jackson and the leadership of the NAACP boycotted white-owned stores in the black business district that would not hire black workers. Black parents fought for the creation of secondary schools for their children. These schools remained segregated, but in a landmark case, a young Baltimore lawyer named Thurgood Marshall assisted NAACP attorney Charles Houston in arguing successfully for the right of Donald Murray to be admitted to the University of Maryland law school. In Maryland, as elsewhere throughout the nation, limited progress under New Deal programs led to a massive, and seemingly permanent, shift of black voters to support the Democratic Party.[13]

Whatever their successes, New Deal programs did not ultimately end the Depression. What brought returning prosperity was the growing investment in defense industry infrastructure as European and Asian nations began rearming late in the 1930s. The resulting defense contracts stimulated the economies of Baltimore, Hagerstown, Cumberland, and other Maryland communities that manufactured airplanes, tires, clothing, vehicles, steel, and ships. As war engulfed Europe, and it became clear that the United States would be drawn into the conflict in support of England and France, the federal government invested more than $185 million in the construction of defense plants in the state of Maryland.[14]

The Project: Roy Stryker and the Historical Section

The photographs reproduced in this book are not simply a reflection of the experiences of those who lived in Maryland during the Great Depression and the beginnings of World War II. They are also a product of the purposes and goals of the larger agency that produced them, of the director of the agency who set policies and hired photographers and sent them out on assignment, and of the photographers who carried out the work of the agency. In the case of the FSA/OWI photographs, those influences are both straightforward and complex. Forty-four photographers who worked at one point or another during the eight years made the images for their boss, Roy Stryker, the director of the Historical Section, who in turn oversaw the creation of these photographs for the larger purposes of the Farm Security Administration (FSA), a federal agency charged with initiating and implementing programs to assist the poorest third of the nation's farmers during the 1930s. The origins of the Section and the biography of Stryker are closely intertwined. In fact, you could say that the personality of Stryker lies at the heart of the images in the FSA/OWI files, although he himself almost never took a photograph.

Roy Emerson Stryker was born in Kansas in 1893 and grew up in Colorado. After serving in France in WWI, he worked on a ranch and attended the Colorado School of Mines. Though he lived most of his adult life in big cities, in one corner of his mind Stryker was always a small-town western country boy for whom the land was important and the education of farmers a way to preserve it. In 1921 with his new wife, Alice, Stryker moved to New York City as a graduate student in Columbia University's school of economics. There he worked for Rexford G. Tugwell, the young agricultural economist who was just beginning a brilliant career as an academic. Tugwell later became an advisor to Franklin D. Roosevelt in his roles as governor of New York and president of the United States. It was Tugwell who introduced Stryker to photography, first by sending him out into the streets of New York to find photographic images to illustrate the economics lessons they were teaching

in the classroom, and then by putting him to work searching for images to illustrate the monumental work they co-authored, *American Economic Life*, published in 1925.[15]

Two important influences from these beginnings are particularly relevant to Stryker's role as director of the Historical Section. First, as a western farm boy he knew about the economic and physical hazards of working on the land and had seen the impact of rural poverty on real people. Then at Columbia he became a trained agricultural economist who understood the larger forces that lay behind the cycles of rural poverty. Secondly, through his experiences at Columbia he came to regard photography as a tool for visualizing those forces and their effects. In short, as a man with first-hand experience in rural work habits of physical contact with the land, he learned to see that reality second hand through photography, and to teach others how to see it as well.

Stryker's mentor, Rexford Tugwell, became one of newly elected Franklin D. Roosevelt's principal advisors in 1932. Roosevelt invited Tugwell to leave academia for federal government employment in 1935 and charged him with responsibility for organizing an agency to be called the Resettlement Administration (RA). Tugwell envisioned three tasks for the new agency: the first two concentrated on helping the nation's poorest farmers by providing financial aid and agricultural advice to marginal farms that still had the potential to be productive and relocating farm families from unproductive lands to cooperative farm communities with undamaged or more fertile soils. The third goal was to create suburban communities to provide housing for poor urban dwellers on undeveloped lands outside of but close to overcrowded and economically depressed cities.[16] Remembering the effectiveness of the photographs they had gathered to illustrate *American Economic Life*, Tugwell brought Stryker to Washington, D.C., to create a file of photographs of agricultural activities for his new agency. Based on their experience in the classroom and in writing their book, they expected they would need a large file of photographs on which they could draw to illustrate reports, to provide a ready source of images upon request for the press and other government agencies, and to show to Congress to justify their agency's mission. Thus was born the Historical Section.

The Resettlement Administration was not the first agency to engage photography's power to illustrate and persuade. The Child Welfare Committee hired Lewis Hine early in the twentieth century to document the evils of child labor. Both the Department of Agriculture and the U.S. Fisheries and Wildlife Commission hired photographers to illustrate the work of their agencies in the 1920s. Many of the New Deal agencies established photographic sections to document their accomplishments: the Civil Works Administration, the Civilian Conservation Corps, the Federal Emergency Relief Administration, the Rural Electrification Administration, the Tennessee Valley Authority, and the Works Progress Administration all hired photographers. Although many of

their photographs survive in the National Archives, none have had the impact of Roy Stryker's small Historical Section for the RA, FSA, and OWI.[17]

The RA was controversial from the beginning. Tugwell assumed that the poorest farmers couldn't survive on the small plots of marginal land they were farming and that, as a consequence, they should be relocated to more productive land and taught to cultivate it using more effective farming methods. To do this he proposed experimenting with such radical ideas as large cooperatively owned and operated farms, cooperative rural and suburban communities, and model migrant-labor camps. His political opponents quickly labeled these ideas "socialism" and "communism." By 1937, the combined fallout from conservative congressional critics, the resistance of state agricultural agencies, and even the protests of poor clients who did not want to be moved from their land led to Tugwell's resignation.

The Resettlement Administration was transformed into the Farm Security Administration, and its less-radical surviving programs were lodged in the Department of Agriculture. There its charge was rehabilitation of farmers rather than resettlement. The FSA regional and local agents accomplished this goal largely through helping their clients get low-interest federal loans intended to reduce farm tenancy and preserve small family farm ownership, and through educational programs helping farm owners and their families improve their efficiency and productivity. After 1941, wartime demands for agricultural products made these programs less essential, and Congress severely reduced the FSA budget. By many measures, it was one of the least known, but most successful New Deal agricultural programs. By the time the agency was dismantled altogether in 1946, half of the 893,000 farm families to whom it had extended nearly $1 billion in credit had already repaid their loans in full; all but a handful had done so by 1950.[18]

In Maryland, the major effort toward establishing a cooperative community was not agricultural, but suburban: the creation of the model town of Greenbelt.[19] Much of the rest of the work in Maryland of the RA, and then of the FSA, was in less-controversial programs. To be sure, black farmers in St. Mary's County were encouraged to form a cooperative to buy a horse, and FSA agents supported dairy farmers in central Maryland in organizing a cooperative to pick up and market their milk. The photographs give evidence that much of the agency's work in the state involved not even that level of social experimentation, however. Farmers were taught plowing methods to prevent erosion; home demonstration agents taught the farmers' wives safe canning methods. FSA agents gave rural people detailed instructions for building safe wells, sanitary privies, and screens for doors and windows, all aimed at improving the health as well as economic security of FSA clients.

The Historical Section was one of the departments of the RA that moved administratively into the FSA in 1937. In 1942 the Section made another

transition. The lead-up to this can be seen in 1939, when the FSA was affected by severe budget cuts, its work winding down as war in Europe and a resulting demand for American agricultural supplies began to bring prosperity to American farmers. During the next two years, Stryker took on war-preparation assignments from other agencies to keep his photographers and support staff on the payroll. As a result his photographers were sent to find stories and images of the transportation industry coping with increased production, of vital wartime industries such as oil refining, of uniformed soldiers returning home on leave to their happy families, and of aircraft workers turning out planes for the war effort. One of the most important of Stryker's "client agencies" was the Office of War Information, or OWI. Created in July 1941 as the Office of Coordinator of Information, the OWI was an umbrella agency designed to prevent duplication of the growing number of government information and propaganda efforts, and it had oversight responsibilities both domestically and overseas. When the OWI was renamed and placed under the Office of Emergency Management in 1942, its associate director Milton Eisenhower, a long-time friend of Stryker's, arranged for the transfer of the Historical Section into the OWI's Domestic Service Branch.[20] Within a short time, Stryker realized he had far less discretionary power within the OWI than he had had at the FSA. Rather than see his file dismantled and dispersed in the service of wartime propaganda, late in 1943 he arranged for the entire file to be transferred to the Library of Congress, and at the age of fifty he resigned from government.[21]

For the next seven years, Stryker worked for Standard Oil of New Jersey, creating there another massive photographic file of 68,000 images whose purpose was to "document the impact of oil on the American people." In 1950, the industrial leaders of Pittsburgh persuaded him to move to their city to document the "Pittsburgh Renaissance," the massive rebuilding of the central city. The Pittsburgh Photographic Library (1950–53), created yet a third collection headed up by Stryker of 20,000 photographs. When he finally retired to Colorado in the late 1960s, Stryker was aware that the FSA/OWI photographs had begun to attract considerable attention, and he knew before his death in 1975 that the file he and his photographers had created would survive as an important legacy.[22]

From the beginning Stryker's Historical Section photographs had a public relations purpose. Critics of the FSA/OWI photographs in the 1980s argued that this made them unreliable as historical evidence, even regarding them instead as deliberately deceptive propaganda.[23] Such critics ignored the importance of the training that Stryker experienced at the hands of Tugwell—namely that most economic problems are complex and need to be seen from many angles and points of view. What came to be known as "The File" did indeed include images of RA and FSA actions, agents, and successes,

but it also reflected the reform-mindedness of its director and many of its photographers. Moreover, the first experienced photographers he hired—Carl Mydans, Walker Evans, and Dorothea Lange—saw photography as an art form as well as a visual record. And finally, Stryker the educator had a goal more ambitious than that of his parent agency; he understood that technological advances would soon change rural patterns of life dramatically, and he saw the accumulating file of photos as an opportunity to record how people did things in the old ways, how they lived their lives. The official purpose for which Tugwell had brought him to Washington was to document the work of the parent agency, but Stryker dreamed instead of "a pictorial encyclopedia of American agriculture."[24]

The photographic work started slowly. It took place in two distinct phases and locations: back in the Washington headquarters—where Stryker, a darkroom and supply room, secretaries, and a growing file of images formed the central core of the operation—and out in the field wherever RA or FSA agents worked with farmers. Stryker hired photographers, supplied them with cameras, film, and flashbulbs, and frequently gave them books to read about the place or the agricultural activity they were about to see. From the beginning he also sent them out with a general set of instructions of the kinds of things to look for. These became known as "shooting scripts," although they in no way resembled the tightly controlled imagery that term came to mean in movies or documentary films. Rather than dictating a preconceived story, Stryker's "scripts" were meant as a guide for creating an awareness of the multiple approaches from which farm and rural community problems ought to be studied and recorded.[25]

By 1937 the project had developed an effective working routine. During the photographers' travels, Stryker kept in touch with them by telegraph and with long letters of reaction, instruction, and observation. Photographers requested camera equipment and film supplies and received these at post boxes and hotels all over the country. A few created makeshift darkrooms in hotel bathrooms and developed (but didn't print) their own negatives; most sent film back to Washington where an efficient staff in a well-equipped darkroom processed the film, assigned negative identification numbers, and printed proofs or "first prints" from which Stryker selected the best images to send back to the photographers in the field for captioning. Early in the project, the 35 mm negatives for images Stryker had not selected were "killed" by punching a hole in the negative. Later, and for larger format negatives, Stryker indicated his selections by tearing the corners on the rejected "first prints" before mailing them for captioning, giving the photographers an opportunity to agree or disagree with his decisions. The photographers did not write captions for these rejected images and the description of "killed" was applied to the negatives of these prints as well. Although in the first year of the project

these killed negatives were destroyed or given to the photographer, for most of the life of the FSA/OWI killed negatives remained in the files and are among those digitized and available for study today on the Library of Congress website.[26]

The captioned photographs were pasted on cardboard mounts and placed in the file, which became an instant illustration library and a frequently used source for newspapers, magazines, book editors, agricultural reformers, and FSA and other government agency heads. Herman Nixon used many of them in *Forty Acres and Steel Mules* (1938), Sherwood Anderson in *Home Town* (1940), and Richard Wright in *Twelve Million Black Voices* (1941). Walker Evans's collaboration with James Agee in *Let Us Now Praise Famous Men* (1941) grew out of an assignment he did for the RA/FSA. *Life, Look*, and *Fortune* magazines regularly included images acquired from the FSA file.[27] When Henry Luce launched *Life* in 1936, he did so after conversations with Stryker about the RA file and the potential for creating photographic stories. Stryker and his laboratory staff also organized exhibitions, including one of massive images mounted in New York's Grand Central Station in 1938. He also loaned photographs to exhibitions organized by others—Walker Evans organized an important exhibit at the Museum of Modern Art in 1938. The photographs became, in short, the visual memory bank of the Depression years for both contemporary and later users.[28]

Although Stryker actively sought and promoted the use of the Historical Section's photographs, for him and for many of his photographers, the greater value was in the growing diversity and comprehensiveness of the file. Arthur Rothstein, whom Stryker hired in 1935 to set up the darkroom and who was, along with Stryker, one of the longest-tenured employees of the Section, described the significance of the file when he was interviewed in 1964 in an oral history project sponsored by the Archives of American Art:

> When I worked for the Resettlement Administration . . . [the pictures] were taken as a historical record. The emphasis was on the quality of the photography as a means of getting across information and at the same time preserving a certain amount of artistic interpretation, using the fine arts aspect of the photographic medium to explain and show what life was like in that particular part of the country. . . . In the case of the Resettlement Administration the picture *was* the end. . . . The idea was to get pictures in the file.[29]

The photographers themselves always felt that because of this larger purpose, the weakest part of their project was the captioning process. Taking notes while working on an assignment had to be juggled with the more familiar activity of operating the cameras and the tricky process of creating rapport with sometimes shy or reluctant subjects. The captions, perhaps composed from sketchy impressions jotted down in the field and reconstructed later

in a hotel room, were not put with the images until weeks later, when Stryker sent approved contact first prints to the photographer at his or her next assignment destination.[30]

The effort to document wartime activities brought another set of difficulties. The heightened security meant that even as his supervisors demanded images proclaiming the effectiveness of the war effort and the determination of the American people to win, Stryker had increasing difficulties getting clearance for his photographers to get into the plants to get the pictures. Marjory Collins ran into trouble in Lititz, Pennsylvania, for instance, when she was detained for not having what overzealous guards regarded as proper identification to photograph the "Animal Trap Company of America." Stryker had to appeal all the way to the head of his agency to get her camera equipment released. Security clearances to photograph, and then censors' permission afterward to publish images, consumed more and more of Stryker's time and energy. Examples of particularly troublesome shoots include the petroleum industry in the west, the coal industry in Pennsylvania, Jack Delano's story on the Atcheson, Topeka and Santa Fe Railroad, and Arthur Siegel's assignment to document thoroughly the building of Liberty and Victory Ships in Baltimore.[31]

Massive as it is, the file that Stryker and his photographers created so carefully nevertheless has important gaps. During the early years of the RA and the FSA, the focus of the larger agency was on problems in the agricultural segment of the economy. Not until after conversations late in 1936 with Robert Lynd, the sociologist who had aroused interest in America's small towns in *Middletown: A Study in American Culture* (1929), did Stryker encourage his photographers to include activities in rural towns in their assignments. Until the shift away from agricultural subjects, and toward the war effort, urban centers were never among his top priorities. Stryker's budget at the Historical Section was always under attack from other divisions within the FSA; in lean times, he had only one or two photographers on his staff, and limited funds to support their travel. Maryland was fortunate; close to headquarters, it received frequent visits and attention from Stryker and his photographic staff. But even there, the larger historical documentary purpose of the file was dependent upon connection with a specific project or an FSA field office manager's need for images.

In a lecture at the Institute of Design in Chicago in 1946, Roy Stryker modestly dismissed himself as "just a guy that hangs around the office and gets paid for buying film and keeping the nuisances away from the photographers so that they can go out and get something done."[32] With his support, the photographers did indeed get something done. The file that they created has become an important part of our national historical memory, the source of our collective visual image of how the nation survived depression and war, and of its people carrying out everyday activities in ways that neither they nor the photographers could have imagined would change so dramatically,

and so quickly. We see farmers plowing with horses, children in one-room schools heated by cast-iron stoves, signs that segregated white from "colored" Americans in employment lines and movie theaters, children struggling to carry buckets of water from the family well to the kitchen. Perhaps never again will such a talented group of photographers, informed by social consciences sensitized by the economic crisis through which they too were living, be given the direction, the freedom, or the funding to record what they saw in such detail.

The Photographers: Biographical Sketches

Maryland is close to the nation's capital, and from 1935 to 1943 it was a convenient destination for photographic assignments both when certain kinds of pictures were needed quickly and when Roy Stryker wanted to send a new staff member on an initial nearby assignment to check out his or her work. As a result, Maryland is featured in the work of many of the most prolific of the FSA photographers. Twenty-six of the forty-four men and women who worked for Stryker at some time during the eight years of the Historical Section's existence completed one or more assignments in Maryland. Of those, eighteen are represented by one or more photographs in this collection. In contrast, more distant states were visited less often, usually by a dozen or fewer of the FSA photographers.[33] Intriguingly, three of the best-known photographers from the FSA did not do any work for Stryker within the state of Maryland: Walker Evans and Dorothea Lange photographed in nearby Pennsylvania and West Virginia, and Gordon Parks did extensive work in Washington, D.C., but none of them ever trained their lenses on the Old Line State.

In studying photographs it is useful and important to know something about the people whose vision imagined and produced them. In the last thirty years, the lives and careers of many of Stryker's photographers have increasingly become of interest to historians and art historians. The FSA/OWI photographic project has achieved international acclaim, and the photographers who created its images are revered as significant artists even as the images themselves have been celebrated as art but sometimes called into question as a reliable historical record. In the 1960s, the Archives of American Art sponsored an oral history project in which Richard Doud conducted extensive interviews with most of the project photographers and staff. These interviews are now available on the Internet. Biographical information for many of the photographers—particularly those who worked for Stryker before 1940—has appeared regularly in published biographies, in doctoral dissertations, in journal articles, and in standard dictionaries and encyclopedias for contemporary photography. Nevertheless, for a few of the photographers who worked in Maryland, relatively little is known about their lives or careers, particularly those who worked

for the agency during the hectic war years, or whose photography was done primarily for other agencies and then acquired for the FSA/OWI file.[34]

The biographical sketches that follow, then, are intended to whet the reader's appetite to know more about some of these remarkable people. The work with the Farm Security Administration was, for many of them, the beginning of long successful careers in photography. But whether they continued on or not, they were profoundly influenced by the experience.

Esther Bubley (1921–1998) first worked with photographs in her Superior, Wisconsin, high school, where she was picture editor of her yearbook. After studying English as an undergraduate, she found work as a photofinisher in Duluth, Minnesota, later enrolling in the Minneapolis School of Design. She left the Midwest for the East Coast in 1940. Edward Steichen befriended her in New York, leading to a brief job at *Vogue*, after which she found more permanent work as a microfilmer for the National Archives in Washington, D.C. It was from this post that Stryker hired her as a darkroom technician for the Office of War Information (1942–43). Though not officially on Stryker's photographic staff at first, she took her camera into nearby neighborhoods and communities in her spare time, and Stryker included many of these images in the FSA/OWI files, eventually sending her on photographic assignments. Perhaps the best known of these is her series documenting servicemen and others riding Greyhound buses during wartime restrictions on train and automobile travel. When Stryker left the government to work for Standard Oil of New Jersey in 1943, Bubley was one of the first photographers he hired, and the work she did for him at SONJ helped to establish her reputation since as one of the stars in the FSA/OWI pantheon of photographers. She worked for Stryker again briefly in his short-lived Pittsburgh Photographic Library project. She spent most of the remainder of her career as a photojournalist in New York City, where her images appeared regularly in *Life* and *Ladies Home Journal*.[35]

John Collier, Jr. (1913–1992), was born in New York State but attended the San Francisco Art Institute in California where he studied mural painting under Maynard Dixon. Dixon was photographer Dorothea Lange's first husband and Lange a long-time Collier family friend. In 1935 she encouraged and inspired Collier's newly awakened interest in photography, in which he was largely self-taught. By September 1941 he had made his way east to Washington, where he joined Stryker's staff as the last photographer hired for the FSA. Before leaving to serve in the Merchant Marine from 1943 to 1945, he sensitively photographed communities of African-American agricultural workers and watermen on both the Eastern and Western shores of the Chesapeake Bay in images that show his own style and the influence of Lange. After the war, Collier worked for four years as a commercial photographer in New Jersey;

during those years, Stryker hired him to work for the Standard Oil of New Jersey project in Latin America. Between 1951 and 1954 he worked on his own in New York as a freelance photographer.

From the beginning, Collier's approach to photography was anthropological, recording sequential stories and documenting the material culture that defined the lives of his subjects. He was undoubtedly influenced in this direction by his father, John Collier, Sr., who served as Roosevelt's head of the Bureau of Indian Affairs. Collier Jr.'s publication *Visual Anthropology: Photography as a Research Method* (New York, 1967) strongly influenced that field, and he became a professor of education and anthropology at California State University in San Francisco and also taught photography at the San Francisco Art Institute.[36]

Marjory Collins (1912–1985) grew up in Scarsdale, New York, and later in Europe, before attending Sweetbriar College and the University of Munich. She studied photography with Ralph Steiner from 1935 to 1940 and briefly served as managing editor for *U.S. Camera* magazine from 1940 to 1941 before going to work as a writer and then a photographer for the Foreign Information Service (FIS). FIS was a predecessor agency to the Bureau of Publications and Graphics, the part of the Domestic Branch of the Office of War Information into which Stryker's Historical Section eventually transferred. Her photo essay on Lititz, Pennsylvania, documenting life on the home front in small towns epitomized the positive and nostalgic image that the FIS and later the OWI Bureau of Publications publicists wanted for propaganda purposes. Much of her work under Stryker in 1942 and 1943 in Maryland was in the same vein of celebrating American virtues, although Stryker gave her considerable freedom to include other kinds of images in her work. As a photographer who grew to maturity surrounded by the social consciousness that influenced the straightforward documentary approach of the 1930s, her OWI assignments sometimes frustrated her. She described in her unfinished autobiography the tension between documentation of a "real" America for Stryker's files, and the OWI propaganda goals of celebrating "the American Dream: the successful Negro, the well-adjusted Italian-American, the happy Polish factory worker bride, the quaint democratic small town."[37] After the war Collins moved to Alaska briefly, then traveled around the world as a photographic reformer, working for the Center for Democratic Institutions, for the American Public Health Association, and participating as an activist in peace causes and women's liberation organizations.[38]

Jack Delano (1914–1997), born Jack Ovcharov in Kiev, Russia, came to Philadelphia with his parents while still a small boy. His lifetime interest in music began there when he studied violin and viola at the Curtis Institute Settlement

Music School, and then attended the Pennsylvania Academy of Arts. Changing his name to Delano, he traveled to Europe on a music scholarship, taking with him a camera to record the places he visited. Photography soon became his new career. Back in Philadelphia, the Federal Arts Program supported him in a project to document the lives of bootleg coal miners illegally taking coal from closed mines in the anthracite coal fields near Pottsville, Pennsylvania. The resulting exhibition brought him to the attention of Roy Stryker in 1940. Arthur Rothstein had just left the FSA to work for *Look* magazine, and Stryker hired Delano to replace him. Delano stayed with the Historical Section through its move to the OWI until he was drafted into the army in 1943. He was among the five most productive of the FSA/OWI photographers in terms of the number of "lots" or related groups of photographs that he contributed to the file (189).[39] A number of these were in Maryland, including an early assignment in the summer of 1940 to record the trucking activity and the roadside attractions along U.S. Highway 1 connecting Baltimore to Washington. Just before Pearl Harbor, Delano went on assignment to Puerto Rico, where Governor Charles Harwood of the Virgin Islands wanted some photographs to accompany a report. The only FSA documentary photography assignment outside the forty-eight continental states, that visit also began Delano's lifetime affection for the land and the people of the island. After the war, he and his wife, Irene, settled there permanently. He became director of programming for the Puerto Rican Educational Television station and a music teacher at the Puerto Rico Conservatory, in addition to photographing the island and its people.[40]

Sheldon Dick (1906–1950) is one of the less well known of the FSA photographers. Born to wealth and privilege in the Midwest—his father A. B. Dick had made his fortune developing the mimeograph machine—Dick attended Cambridge University and was self-taught as a photographer. Perhaps unexpectedly for a young man of his privileged background, he was an ardent social reformer who used his camera to document conditions of laborers during the Depression. Through his connections with publishers in New York he was introduced to Stryker, who put him on the FSA staff as a photographer in 1937, paying him less than a dollar a year. Though Stryker years later remembered Dick as a "nice boy" who had been used as "a checkbook for the left-wingers of the time," and whose initial FSA photographs of out-of-work miners in the Shenandoah Stryker evaluated as "lousy, just plain lousy,"[41] he kept Dick on for nearly two years and assigned him in July of 1938 to photograph Baltimore's urban neighborhoods. These photographs, and others among the 378 he contributed to the permanent FSA file, belie Stryker's initial judgment, for they reveal an eye for detail and perspective, as well as sympathy for the people he encountered. After his work with the FSA, Sheldon Dick

turned his hand to filmmaking. He died tragically as a result of suicide in New York in 1950.[42]

Theodor Jung (1906–1996) was one of four FSA/OWI photographers of the Historical Section (with Ben Shahn, Jack Delano, and Edwin Rosskam) who were not native to the United States. Born in Austria, by 1912 he had emigrated with his parents to Chicago, where in 1916 he was given his first camera. As an amateur there he was active in the Fort Dearborn Camera Club, influenced by such early photographers as Eugene Atget and Andre Kertsez toward documenting places and people rather than salon photography. In 1934 he went to work for the Federal Emergency Relief Administration in Washington, D.C., preparing pictorial charts of statistical reports on unemployment. In September of 1935, when he heard about the creation of the Historical Section within the Resettlement Administration, he approached Roy Stryker with a portfolio of his photographs. Stryker hired him as a photographer and as a graphic designer and almost immediately sent him to Garrett County, Maryland, on one of his first assignments. The thirty-four photographs he took there are the earliest FSA images of Maryland in the Depression years. Jung remained with the Historical Section for less than a year; in May of 1936 Stryker laid him off, ostensibly for budget reasons, although Jung eventually came to believe that he was let go in part because his photographic approach did not coincide with Stryker's vision for the agency. After leaving the Resettlement Administration , Jung became art director and photographer for *Consumer's Guide*, followed by a career doing the same work for several other publications before he turned increasingly to calligraphy and book design. He also returned to Vienna as a documentary photographer, helping to coordinate there a United States Information Service exhibition of FSA photography in 1975.[43]

Russell Lee (1903–1986) was born in Illinois, received a degree in chemical engineering in 1925, and worked as a chemist for a manufacturer of roofing materials. In 1929 he quit his job as a Kansas City plant manager to attend the California School of Fine Arts then joined an art community in Woodstock, New York, with his first wife, also an artist. He bought his first camera in 1935 with the intention of using it to improve his painting, but soon was won over to the new medium in its own right. Hearing of the photographic work of the Resettlement Administration (later FSA) photographers, he traveled to Washington, D.C., to meet Roy Stryker in 1936. Stryker hired him and sent him on the road for most of the next six years. Much of that work was done in the Midwest, where he traveled with his second wife, Jean, whom he met in New Orleans on assignment in 1938. In the summer of 1939, while Lee was back at headquarters, Stryker sent him briefly to Southern Maryland. Lee was one

of the strongest advocates of the importance of the "file" as a historical record, and it was he who first put into practice the agency's—and Stryker's—new direction of recording in detail the life of the rural towns on which the American agricultural economy depended. Lee's most famous FSA photographs are of Pie Town, New Mexico; he also pioneered photographic work in the black districts of Chicago. Drafted into the army in 1942, after the war he worked occasionally for Stryker for the Standard Oil of New Jersey and Pittsburgh Photographic Library projects. He began teaching in the University of Missouri Photo Workshop in 1948, becoming its director in 1953; in 1965 he left Missouri to join the faculty of the Department of Fine Arts of the University of Texas.[44]

Edwin Locke. Little is known about Locke. He served as Roy Stryker's assistant at headquarters from 1935 to 1937. In 1937, he wrote the script for a Pare Lorentz documentary film, "Power and the Land," one of several films with which Roy Stryker and his project photographers were involved. Stryker talked fondly of Locke in his several interviews with Richard Doud, referring obliquely to his death. His most extensive photography for the RA/FSA file is of Arthurdale, an experimental community in West Virginia that predated the Greenbelt communities developed under the Resettlement Administration.[45]

Carl M. Mydans (1907–2004) was born and educated in Boston, Massachusetts, where he studied journalism and worked as a journalist for the *Boston Globe* and the *Boston Herald*. To expand his ability to provide telling details in his news stories, in 1931 he bought a Contax 35 mm camera and moved to New York, where he became a reporter for *American Banker*. Roy Stryker selected him in 1935 as one of the first photographers hired for the Resettlement Administration, and Mydans provided a key part of Stryker's education on the potential for and use of photography, particularly the possibilities for intimate or informal portraiture provided by the small 35 mm camera. In the fall and winter of 1935–36, Stryker sent Mydans on several assignments to document the work of building the Resettlement Administration's showcase for suburban development, the cooperative town of Greenbelt. Later, Stryker assigned him to an extensive trip through the southern states to document the cultivation of cotton, where he focused his lens with compassion and insight on the poverty and dignity of the black and white workers worn out, like the soil they tilled, by the still primitive agricultural techniques that dominated cotton growing. Though Mydans stayed at the Historical Section of the Resettlement Administration only briefly, his influence on the agency was enormous. In 1936 he became one of the first staff photographers of *Life* magazine, remaining there for forty years as a photographer and war correspondent

covering the Russo-Finnish War (1939), World War II (both in Europe and the Pacific (1940, 1942–45), Korea (1950 and 1951), and Vietnam (1968). When *Life* ceased publication in 1972, he became a senior photographer for *Time* magazine.[46]

David Myers. In the Library of Congress online catalogue of FSA/OWI photographs this photographer's name is followed by an alternative [David Moffat] in brackets. Nothing more is known of him as a photographer or of his work. It is possible that his photographs are among those that were not created for the agency but were later donated to or included in the FSA/OWI file, where 81 photographs, all from 1939, mostly of Washington D.C., are attributed to Myers.

William Perlitch (1923–1987). Little is known about Perlitch beyond what can be gleaned from the captions accompanying the 207 photographs he took that are still in the Office of War Information files and from the bare-bones birth and death data recorded for him in the Social Security Death Index. In the fall of 1942, before Stryker and the Historical Section became part of the Bureau of Publications of the Domestic Branch of the OWI, Perlitch completed several assignments for the News Bureau of the OWI concentrating on high school students preparing to participate in the war effort. One of his visits was to Montgomery Blair High School in Silver Spring. Though the thirty-eight photographs and their captions in the FSA/OWI file are largely of the "propaganda" variety that so troubled his OWI contemporary Marjory Collins, they show considerable skill for a photographer not yet twenty years old and record the degree to which the war effort permeated almost every aspect of life on the Maryland home front, even for those teenaged girls and boys learning welding, building model airplanes, and doing calisthenics as part of their high school "victory corps."

Ann Rosener (1914–). Almost nothing is known about Ann Rosener, although she left a considerable body of competent work done for Stryker in the OWI during 1942 and 1943, including assignments at Baltimore's Johns Hopkins University Hospital in May of 1943 and a thorough documentation of activities at the Holabird Ordnance depot that same month.[47]

Edwin Rosskam (1903–1985) was born in Munich, Germany, to American parents and lived there until after the First World War. After returning to Philadelphia with his mother in 1919, he attended Haverford College for a year, then studied art at the Academy of Fine Arts. Like many other young American artists, he traveled to Europe during the 1920s; there he became interested in photography, eventually spending three years in Polynesia sponsored by

the European Press Syndicate. He did not return to the United States until the early 1930s. On his return he worked first for the *Philadelphia Record* with his new wife, Louise Rosenbaum, a photographer in her own right, and then as a freelance photographer for *Time* and *Look*. By his own account, his coverage of a political story in Puerto Rico did not fit the image those magazines wished to portray, so the photo-essay story he prepared was never published. Like the image of the Maryland countryside in 1936 which appears in this book, the Puerto Rico photographs were part of his private collection which he and Louise donated to the file when he came to work for the FSA. Roy Stryker hired him in July of 1939 as a layout and photo-editing specialist, and he played a major role in creating some of the large photo-murals that the FSA staff pioneered in designing. Although he was not officially a photographer—he complained to Doud during the oral history interview completed in 1965 that Stryker needed him too much in the Washington office and would not send him out on assignment—he was able to do some photography on his own in nearby Maryland. Rosskam left the Historical Section in 1941 to return to freelance work. He cooperated with Richard Wright to produce *Twelve Million Black Voices: A Folk History of the Negro in the United States* (New York, 1941). In 1943, Stryker hired both the Rosskams as project photographers for the Standard Oil of New Jersey (SONJ) project staff. They worked for Stryker at SONJ until 1946 when Rexford Tugwell invited them to return to Puerto Rico, where he had become governor, and put Edwin Rosskam in charge of creating a picture file of the island modeled on the FSA/OWI file. The Rosskams returned to the mainland in 1953, settling in New Jersey to raise their two children.[48]

Arthur Rothstein (1915–1985), who shared with Russell Lee the distinction of having produced the most number of "lots" or related groups of photographs in the FSA/OWI file, was born and educated in New York. He was fascinated by photography as a high school student, and while an undergraduate at Columbia University ostensibly preparing to go to medical school, he worked with agricultural economists Rexford Tugwell and Roy Stryker in their project to copy and collect photographs to illustrate their study of American agriculture. In 1935 when Tugwell founded the Resettlement Administration and hired Stryker to head the Historical Section's photographic project, Stryker chose Rothstein to establish the photographic laboratory and work as a photographer. There he met and was influenced by Walker Evans, and admired the work of Ben Shahn and Dorothea Lange. He eventually became one of the FSA's key photographers, working for Stryker for the next five years. During those years, despite almost constant travel in the rest of the United States, he photographed extensively throughout Maryland, beginning with his documentation of the construction work in Greenbelt in November of 1935. In 1940, he left FSA to

work as a photographer for *Look* magazine, returning briefly to work under Stryker in the Office of War Information in 1942 (during which time he completed an assignment in Baltimore). Later that year he was drafted and served in India, Burma, and China for the U.S. Army Signal Corps. From 1946 until 1971 Rothstein was director of photography for *Look*, and from 1972 to 1976 director of photography and associate editor of *Parade* magazine. The gentle charm of his FSA "people" images illustrates the effectiveness of a photographic technique that became a staple of photojournalism, the "unobtrusive camera," a technique that Rothstein claimed he had originated.[49]

Ben Shahn (1898–1969), like many of the photographers whose work makes up the FSA/OWI file, was first an artist working in other media, in his case primarily as a painter, before he became a documentary photographer. He was born in Lithuania, migrated to the United Sates at the age of six, and attended City College of New York and the National Academy of Design. He worked as a lithographer's assistant beginning in 1911 (at the age of thirteen), took courses in painting at the Art Students League, and traveled to Europe to study art in the 1920s. After his return to New York, he shared a room with photographer Walker Evans, who helped him learn to use a Leica 35 mm camera as a mechanical sketching tool for his paintings. His paintings of the Sacco and Vanzetti trial brought him artistic acclaim, and he assisted Diego Rivera with the murals at Rockefeller Center. Shahn was working as a muralist for the Public Works Administration when Rexford Tugwell hired him early in 1935 as part of the "Special Skills Division" of the Resettlement Administration. When Stryker arrived in Washington and began to develop the "file" of images for the Historical Section, it became a logical place to put Shahn's photographic production. Thus Shahn became an unofficial but influential contributor to the photographic work of the FSA; his reformist, artistic commitments had an important impact on younger photographers like Arthur Rothstein and John Vachon. Not until 1938 was Shahn actually on the payroll of Stryker's staff, although Stryker supplied him with film and Stryker's lab developed it (Shahn did as much of his own printing as possible). Nevertheless, he can justifiably be regarded as one of the first photographers for the Historical Section of the Resettlement Administration. Hank O'Neal observed of him in 1976 that "Shahn had a social awareness that Stryker initially lacked. . . . [H]is photographs were not just to fill the file; they were to inspire action."[50] He usually traveled with his artist wife, Bernarda Bryson, frequently taking pictures with a small camera he had equipped with a right-angle lens so that he could unobtrusively photograph people going about their daily business. Stryker was supportive of Shahn's continued application for funding to paint murals, and from 1939 until his death in 1969, Shahn returned to his first love, painting, only occasionally producing photographs.[51]

Arthur Siegel (1913–1978), a Detroit-born photographer, is best known today for his work as an innovative contemporary photographic artist who in the 1950s developed experimental techniques in color and the photogram that pushed the limits of 35 mm color photography. But like many of the artists who contributed to the FSA/OWI file, he was a photographer with many interests and skills, and during the early 1940s Roy Stryker called on him frequently for his ability to carry out high-quality commercial industrial photography. Educated in Detroit's public schools, the University of Michigan, and Wayne State University, Siegel became a serious photographer in 1927 while still a teenager, and in 1937 he won a prestigious scholarship from Laszlo Moholy-Nagy to attend the New Bauhaus School in Chicago, which became the Chicago Institute of Design. In 1948 Siegel became a highly respected faculty member there, rising to become chair of the Photography Department before his death in 1978.

Siegel began teaching in the inner city of Detroit in the 1930s, offering photography courses at Wayne State University and in the Detroit public schools; while an advisor to the Chrysler Camera Club in 1941, he invited the then relatively unknown Ansel Adams to Detroit to conduct a photographic workshop. As a commercial freelance photographer in Detroit between 1935 and 1943, he specialized in industrial photography, and it was in this capacity that Stryker contracted with him in 1941 and 1942 to document the transformation of the assembly line industries of Detroit into an arsenal for wartime production. Siegel was thus his photographer of choice when the Historical Section, by then part of the OWI, received permission to document the enormously successful production of Liberty Ships at the Bethlehem-Fairfield Shipyards in Baltimore in May of 1943. Nearly seven hundred of Siegel's photographs included in the OWI file from that assignment provide thorough coverage of every aspect of that work. Siegel also took advantage of being in Baltimore to take a day off from the shipyards to see Count Fleet win the Preakness Stakes at nearby Pimlico Race Course.[52]

John Vachon (1914–1975), a native of Minnesota, went to work for the Historical Section as an "assistant messenger" in May of 1936 when the deepening Depression made it impossible for him to fulfill his original purpose for coming to Washington, D.C., of pursuing a graduate degree in Elizabethan poetry at Catholic University. He was paid $90 a month and his job included writing captions supplied by the photographers on the back of the 8-by-10 glossy prints produced by Arthur Rothstein's photographic lab, as well as delivering packages between government offices. At first he had no real interest in photography; his son remembered that years later he laughingly recalled Roy Stryker telling him "When you do the filing, why don't you *look* at the pictures."[53] By the end of the year, he was not only *looking* at the photographs,

he had met and begun to admire the photographers who took them, and in April 1937 he asked Stryker if he could borrow a camera on weekends to shoot street scenes around him in Washington. In the transformation from file clerk to photographer, Vachon had some of the finest possible teachers. Dorothea Lange, visiting at headquarters on one of her rare trips to the East Coast, encouraged him. Ben Shahn gave him rudimentary lessons on how to use a small Leica and talked to him about street photography. Walker Evans insisted that he learn to use the larger, bulkier 8 × 10 view camera. Although he continued on the staff primarily as a file clerk—one who eventually knew "the file" better than anyone but Roy Stryker because he had created and maintained its in-house organizational system—increasingly he spent his spare time photographing "everything in the Potomac Valley." A few of his photographs of Greenbelt in the fall of 1937 were published in the *Washington Post*, and this book includes a few of his images of Montgomery and Prince George's Counties that Stryker liked well enough to include in the file. Although his title was still "file clerk," in the fall of 1938 Stryker sent him on a solo assignment to Omaha, Nebraska, and from then on he traveled regularly whenever the FSA budget allowed it. In 1940, he became an official "junior photographer" and was the only salaried photographer remaining with the Historical Section when it became part of the Office of War Information in 1942. Drafted into military service shortly afterward, Vachon became a staff photographer for *Look* magazine after the war. The Museum of Modern Art had an exhibition of his work, and in 1973–74, shortly before his death in New York City in 1975, he won a Guggenheim Fellowship to do a photographic study of North Dakota in the winter.[54]

Lieutenant Whitman. The FSA/OWI file contains 177 photographs taken by a Lieutenant Whitman in July of 1942 of Annapolis and the Naval Academy activities there. No further information is available about Whitman. It is probable that his photographs are among those that were not created by photographers working for the agency but were later donated to or included in the FSA/OWI file.

Marion Post Wolcott (1910–1990) was raised in New Jersey by her progressive reformer mother and educated at the New School for Social Research in New York City. She began her study of photography while at the University of Vienna. When she returned to the United States, she taught briefly at a private school in New York State; she made and sold her first professional photographs of the children at the school. She met Ralph Steiner and Paul Strand in New York City, and they encouraged her to quit teaching and begin work as a freelance photographer. Her work appeared in *Vogue, Life,* and *Fortune,* and in 1937 she moved to Pennsylvania to work for the *Philadelphia Evening*

Bulletin, where she was the only woman among its ten photographers. In September of 1938 Roy Stryker hired Marion Post as one of the few women photographers of the FSA. Her first assignment was to document the cooperative community life of Greenbelt, but within a short time Stryker sent her out on the road. She traveled extensively for the FSA and is noted particularly for her photographs in Florida showing the harsh contrasts between wealthy race goers and the abject poverty of migrant workers, and for her exuberant portraits of African-American day laborers dancing at "Juke Joints" in the rural South. She left the FSA soon after she married diplomat Leon Wolcott in 1941 following a whirlwind courtship. Her husband required the agency to change the credit lines on all her file photographs to her new name. For the next thirty years her photography was private, limited to her growing family and her worldwide travels with her husband. Her reputation grew along with that of the other FSA photographers, and when she retired to California in 1974, she returned to public exhibition of her work.[55]

The photographs of Maryland that these nineteen photographers contributed to the FSA/OWI file provide a starting point for telling many stories about the Old Line State in a period of transition and change. None of them reached the iconic status of the handful of images that haunt our national imagination which these photographers and others made during the Great Depression. No Maryland "Migrant Madonna" or "Dust Bowl Father and Son" have come to define to the world what the "Great Depression" looked like. Yet they reflect accurately the middle ground that Maryland represents.

The Photographs

The one hundred and one photographs that comprise the heart of this book have been selected from nearly four thousand images of Maryland in the files of the Historical Section of the Farm Security Administration (FSA) and the Office of War Information (OWI), now housed in the Library of Congress Prints and Photographs Division. Their selection was based on several sometimes competing goals. The first objective was that the chosen photographs should be representative: representative of the diversity of Maryland as a state; representative of the kinds of photography created by the FSA/OWI photographers; and representative of the photographers who worked in the state between 1935 and 1943.

A problem immediately surfaced because not all of the regions of the state received equal attention. For instance, Greenbelt was a showcase for the Resettlement Administration, and Roy Stryker sent photographers there every year between 1935 and 1942 to record its development. Of nearly a thousand photographs of Greenbelt in the file, only a handful are reproduced here. In contrast, there are no photographs at all of the northeastern tier of Carroll, Harford, or Cecil Counties, and relatively few of the Eastern Shore. As much as was possible, however, if a county or a region of the state is represented in the existing file of prints or negatives, I chose to reproduce at least one image. For that reason, not all photographers who worked in Maryland are represented in this collection.

A second priority in the selection of these images was to illustrate the impact of key events and the passage of time in Maryland over the eight years in which these photographs accumulated in the FSA/OWI file. Change over time can be seen most clearly in the division of the photographs into two major sections: the Depression years and the wartime years. But within each of those separate eras, selected photographs span the range of time more evenly than do those in the complete file itself. The central mission of the Resettlement Administration and Farm Security Administration—to alleviate the worst effects of the Depression for rural people—meant that before 1938, urban places and large towns were rarely the object of the photographers' assignments. For instance, Roy Stryker did not send any photographers to Baltimore until July of 1938, three years after the start of his project. The imbalance between rural and urban images shifted in the other direction after 1940. The photographers' assignments to document a nation at war, combined with tight restrictions on gasoline and tires which made it more difficult for them to work in the countryside, meant that there are relatively few photographs in the file of rural activity during the war years.

A final goal in selecting photographs was to choose whenever possible those with a high aesthetic quality. The best photographs in the file go beyond

merely illustrating people, places, or events; the skill and artistry of the photographer transformed the "document" of a documentary photograph into a human contact reaching across the decades, a moment in time transformed into a timeless reminder of the human spirit or the natural world. Some of the images chosen for reproduction in this book are included simply because they are superb photographs.

I have attempted to organize the selected images into groups of related photographs that tell stories about Maryland and its people during a period of rapid change. Those stories are grouped in the first selection of photographs around the different geographic regions of the state. In the second part, representing a much shorter period of time, the photographs are divided between the business of the war effort and the determination of ordinary people to carry on everyday life in the face of the enormous energy and the many restrictions that winning the war demanded of them.

All the captions throughout this section are those prepared by the photographers in the field when they received the set of first prints from the film they had sent to Washington to be processed and printed, often a week or more after the photographs had been taken. The captions they wrote were typed up by secretaries in the Historical Section office and cut into strips that were then glued onto the cardboard mounts above the photographs to be placed in the growing file of FSA images.

Surviving the Depression

Central and Western Maryland | The Seasons of Country Life

Life in the country is organized not by the clock but by the calendar, by the changes from one season to another, and the different hard work that each season brings. The central counties of Maryland, located in what geographers describe as the Piedmont Plateau province and the Great Hagerstown Valley section of the Ridge and Valley province, remained one of two important regions for Maryland agricultural productivity even as the state's economy shifted from agriculture to industry during the first half of the twentieth century.[1] In Montgomery, Frederick, and Washington Counties, settled in the eighteenth century by German farmers, fertile soil and a favorable climate supported fine grasslands and, especially after 1920, a thriving dairy industry. But the region's wheat and corn crop, which in 1910 had led the state in agricultural cash value, were hit hard by declining prices in the 1920s and the terrible drought of 1929. The Agricultural Experiment Station in Beltsville, founded as a Research Center of the United States Department of Agriculture in 1910, worked to find scientific farming solutions to these and other problems, but many Piedmont farmers continued to farm much as their parents and grandparents had, killing hogs in early winter when they had fattened and taking advantage of the colder weather as a means of preserving the meat, preparing fields with horse-drawn plows in the spring, mowing the first crop of hay in the late springtime, helping neighbors harvest the wheat crop in high summer. After World War I, tractors and mechanical harvesters speeded the harvest for some, but many farmers still relied on horsepower until after World War II.

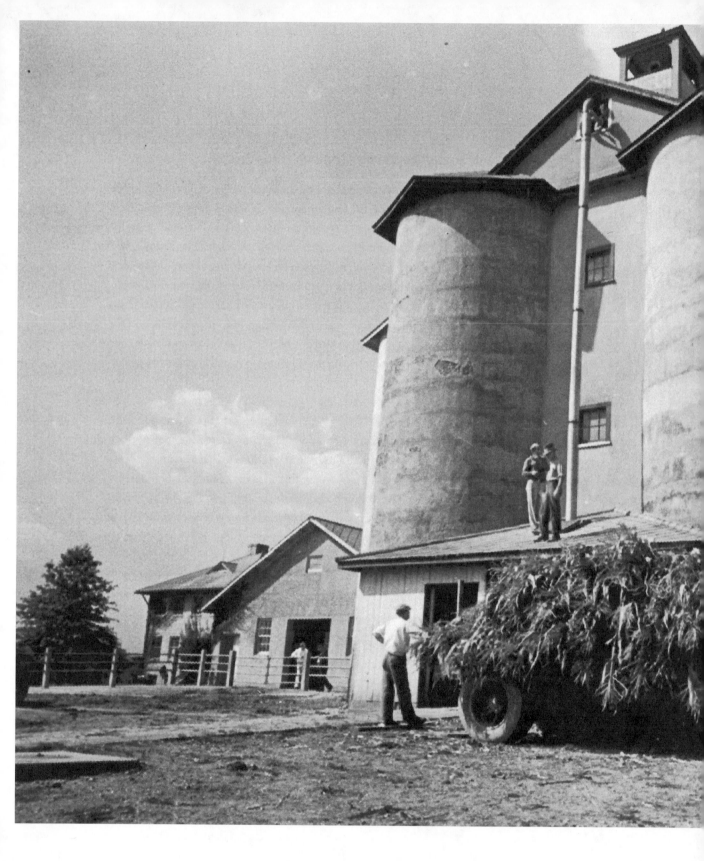

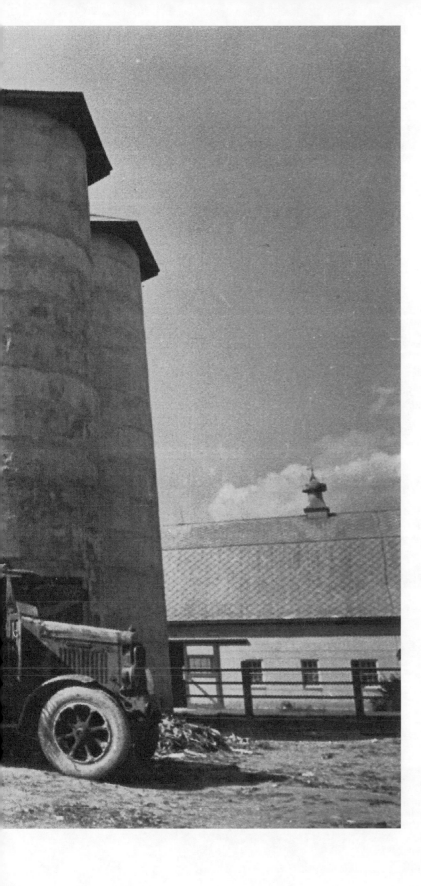

Carl M. Mydans. Beltsville,
Prince George's County,
November 1935. Filling a silo
at the U.S. Department of
Agriculture Research Center.

USF33 000042-M3

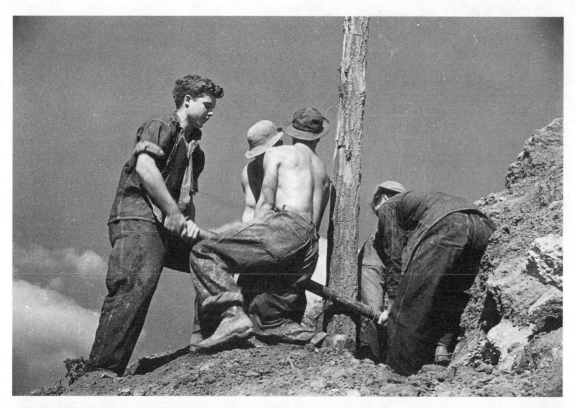

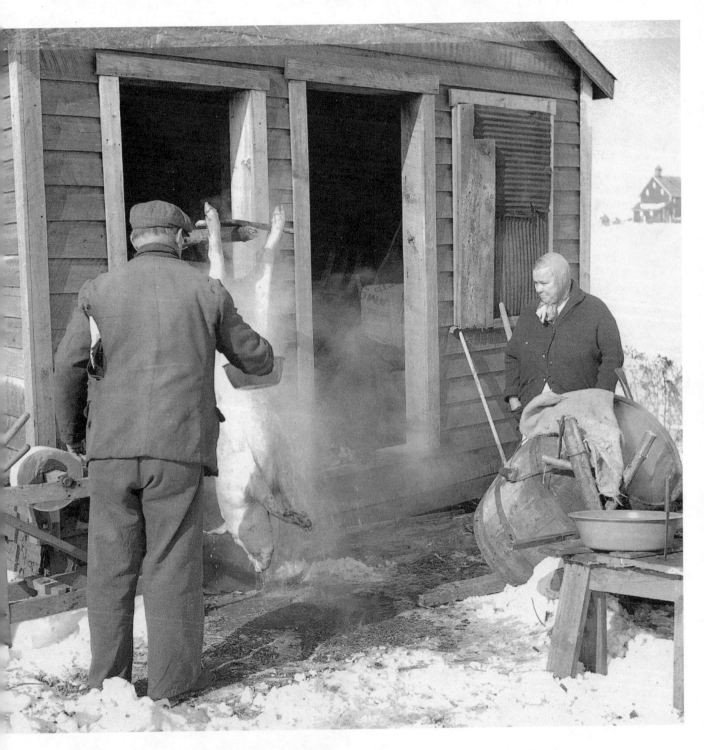

◄ *(top)* Carl M. Mydans.
Beltsville, Prince George's
County, November 1935.
Civilian Conservation Corps.
Boys at work at the U.S.
Department of Agriculture
Research Center.

USF33 000051-M4

◄ *(bottom)* Marion Post Wolcott.
Frederick (vicinity), February
1940. A farmer's milk cans
on the highway waiting to be
picked up by a truck.

USF34 052961-D

Marion Post Wolcott. Frederick
(vicinity). Hog Killing.

USF34 052995-E

Edwin Rosskam. Middletown
(vicinity), June 1941.
Farmer on a harvester.
USF34 012792-D

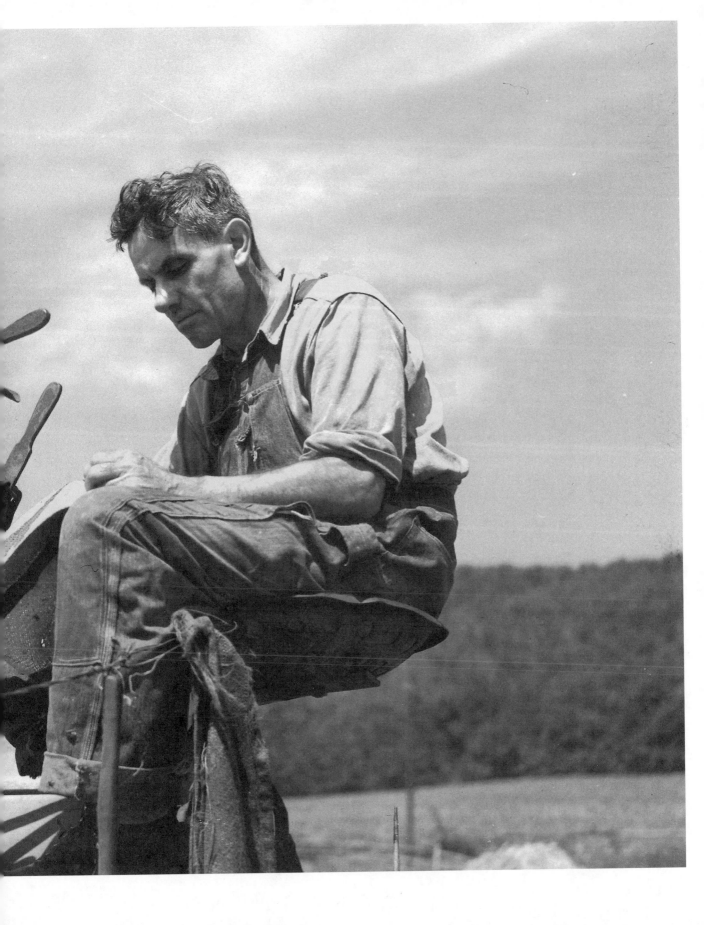

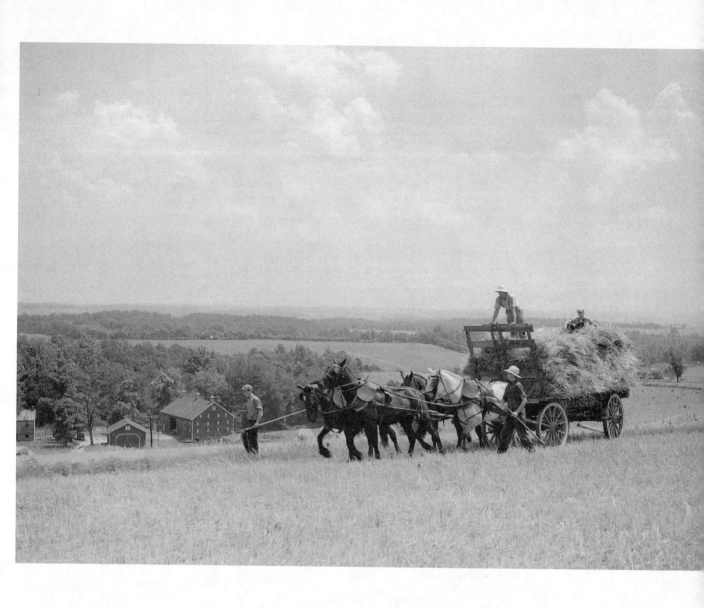

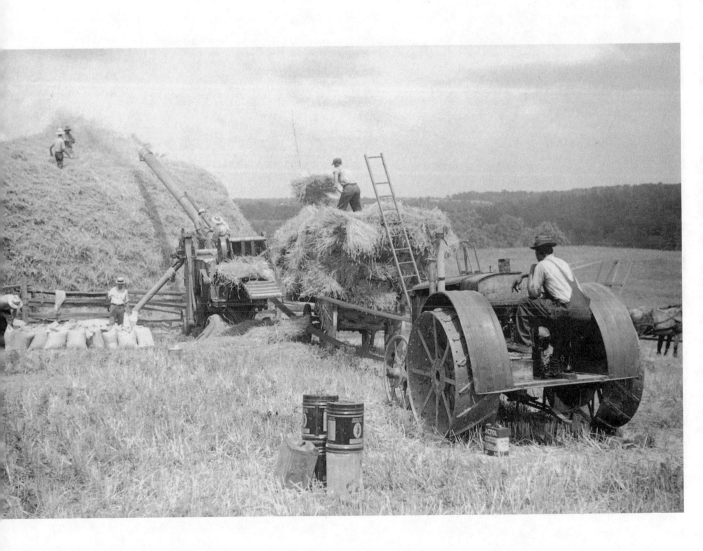

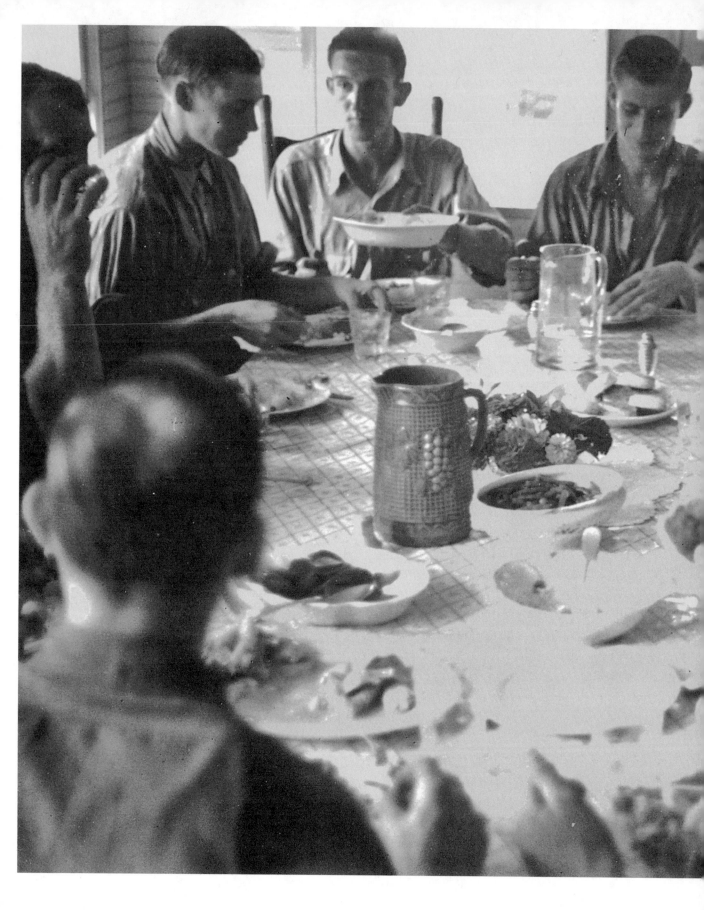

Edwin Locke. Brookville,
July 1937. Farmhands at lunch.

USF33 004321-M4

The Impact of Hard Times — Western Maryland

The contrast between the relatively positive and bucolic rural scenes photographed by FSA photographers in Central Maryland and the abject poverty visible in the images they captured in the region just over the Blue Ridge in far Western Maryland is striking. Allegany and Garrett Counties in the Appalachian region of Western Maryland also remained a farming region into the 1930s, but here the mountainous terrain dictated smaller farms, and many of those living in the region were laborers in the coal mining industry. Corn prices dropped sharply in the 1920s. The losses from this crop, grown by four out of five Maryland farmers at the end of World War I, as well as losses on other grain crops and the drought of 1929–30, drove many back to subsistence farming. Moreover, the deepening Depression wiped out jobs from local industries that had drawn men from the farms and from the coal mines of Allegany County into factories such as the Kelly Springfield Tire Company in Cumberland. The winter of 1935–36 was unusually severe, with deep snow further isolating mountain families and the spring melt flooding the Potomac River below Cumberland.

In the photographs that follow, modern observers might be shocked by the deep gullies of eroded land, or the interiors of houses in which newspapers tacked over exterior boards provided the only insulation from cold, both of which rural Marylanders of the 1920s and 1930s accepted as normal. Such poverty led to malnutrition and its accompanying diseases. When the Bittinger family gathered for a portrait in front of their cabin in 1937, some of them proudly wore their best clothes, while others were barefoot. At least one shows evidence of a severe goiter caused by lack of iodine in the diet. The Resettlement Administration sought to find ways to help these families, and Stryker's photographers found plenty of evidence of their poverty and need.

► Theodor Jung. Garrett
County, September 1935.
Rehabilitation client.
USF33 004013-M3

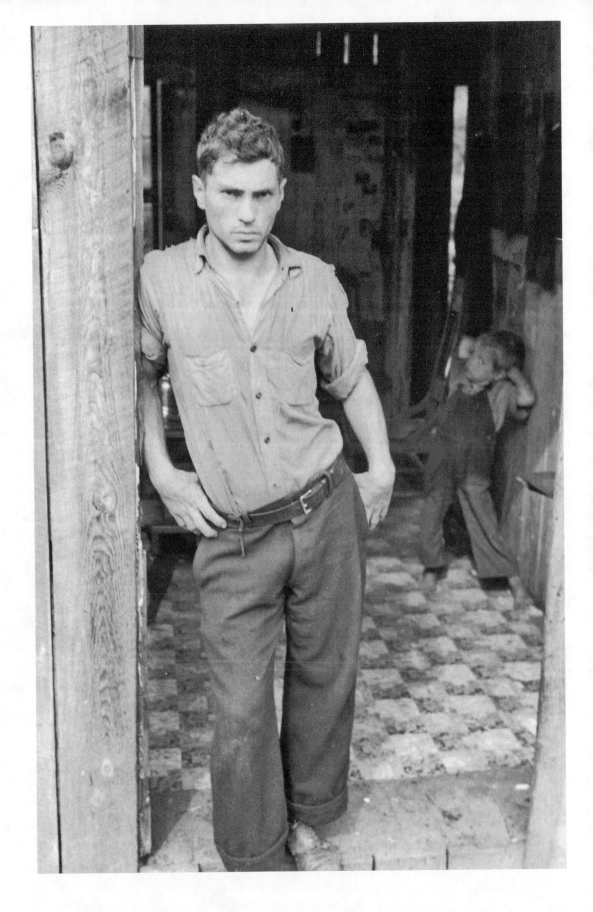

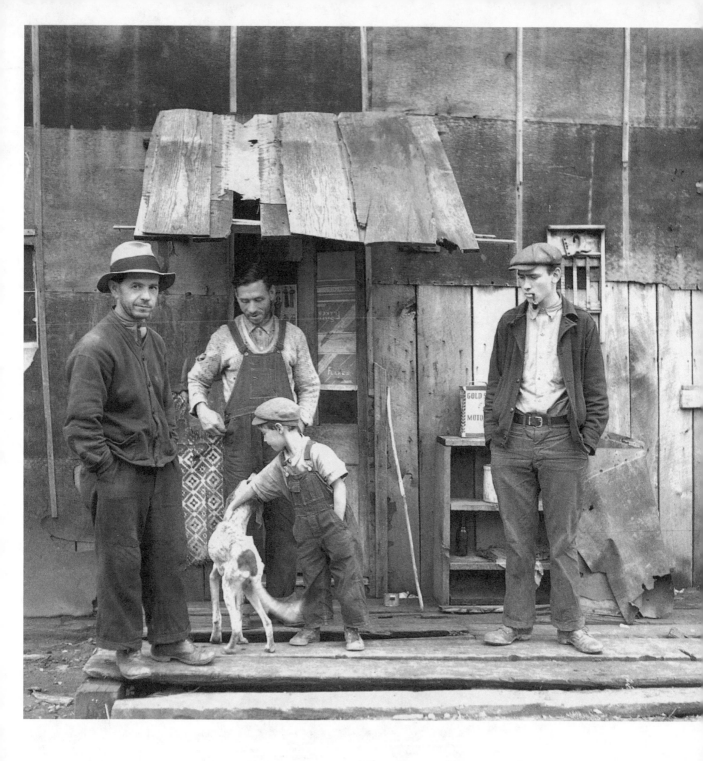

Arthur Rothstein. Garrett
County, November 1936.
Mountain people.

USF34 005574-E

► Arthur Rothstein. Garrett
County, December 1937.
Minnie Knox, a widow who
lives with her daughter
on a farm.

USF34 026097-D

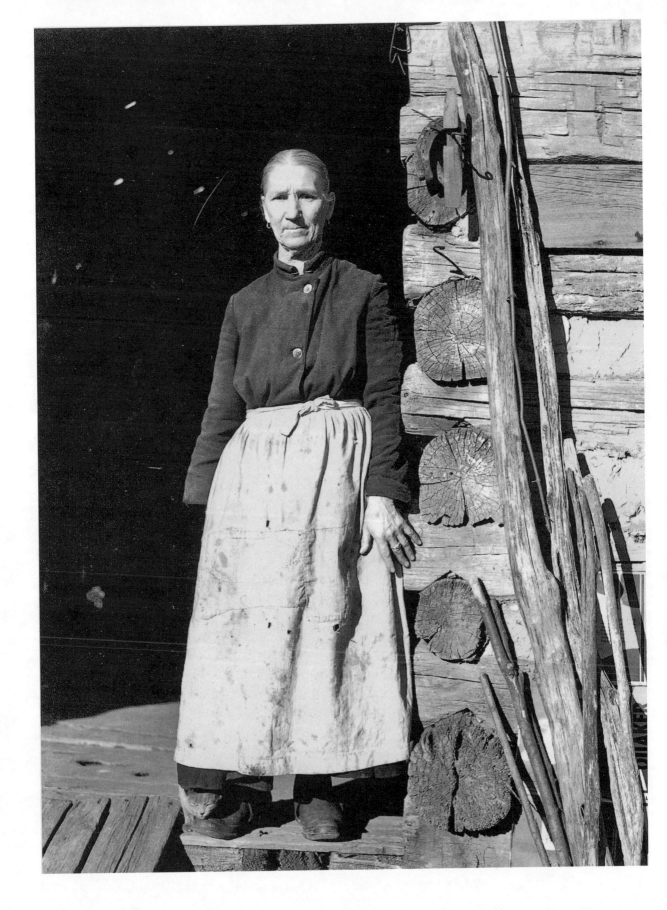

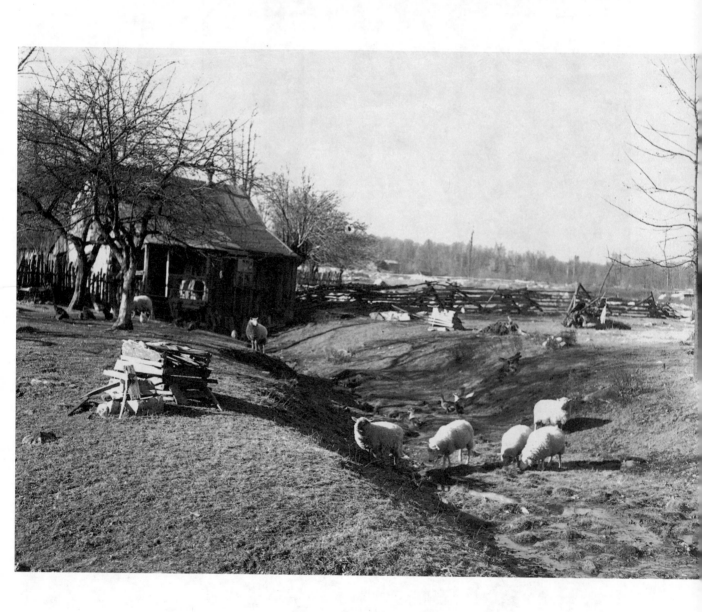

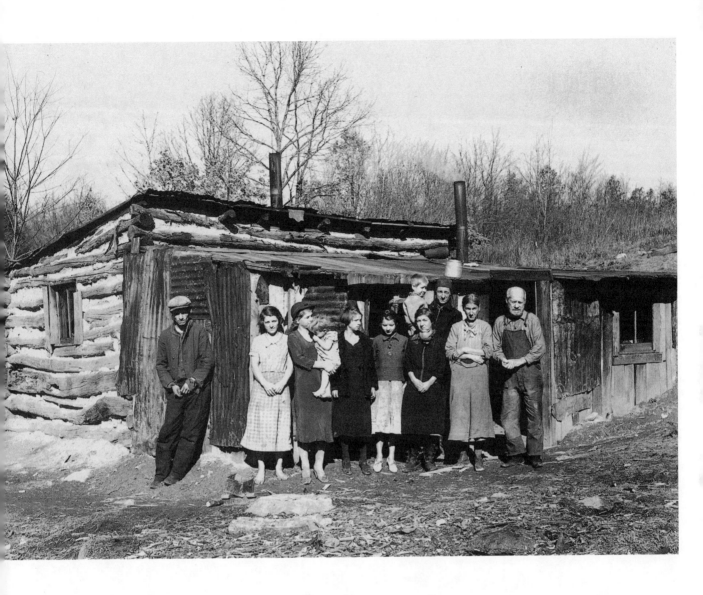

Arthur Rothstein. Garrett
County, December 1937.
The Bittinger family and the
cabin in which they live.
USF34 026095-D

◀ Arthur Rothstein. Garrett
County, December 1937.
Sheep on the farm of
Minnie Knox.
USF34 026104-D

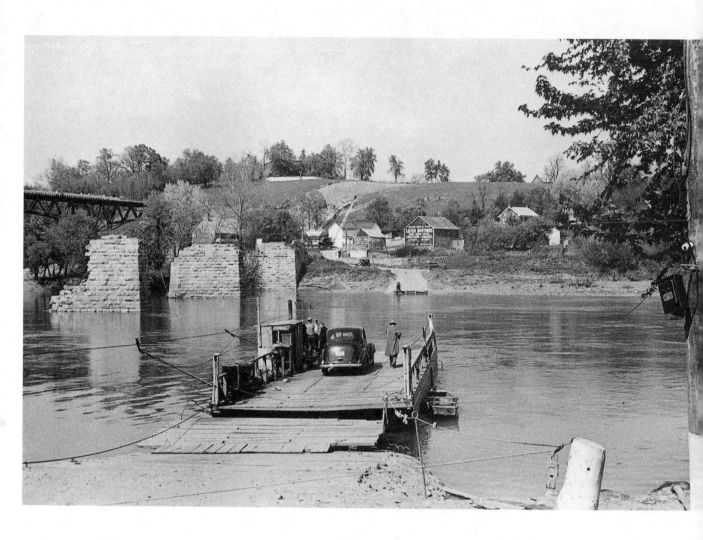

John Vachon. Sharpsburg
(vicinity), May 1939. Ferry
crossing the Potomac River.
USF33 001372-M5

▶ John Vachon. Garrett County,
May 1939. Painting a barn.
USF34 060014-C

Towns of Central and Western Maryland

The agricultural economy of the countryside was inextricably linked to the towns that provided the essential services on which farmers and their families depended. Although towns and town life were not a central part of the Historical Section photographers' assignments until after 1937, from the beginning Stryker's cameramen included images of the towns that served rural needs in their documentation of FSA programs to improve farming methods and farmers' use of the land. U.S. 40, the "National Road" begun in 1806 to connect Maryland to markets across the Allegheny Mountains, continued to serve as an important link between Maryland's western towns. A post office, bus or train station, fire department, hotel and general store, barbershop—these and other establishments provided a sense of community, where farmers, shoppers, and businessmen could meet on Main Street. The severe drought of 1929–30 created economic strains on these communities that became worse as the Depression deepened. The failure of the Central Trust Company of Frederick[2] in 1931 led to the "domino effect" collapse of fourteen other small banks in Western Maryland. Towns like Rockville and Berwyn in the center of the state, or Hagerstown and Cumberland in the west, were equally hard hit by the Depression.

Not all of Western Maryland's towns were connected to farming. In Garrett County, the thriving lumber industry that had supplied timber for railroads and mines at the turn of the century declined rapidly as the Depression hit both the commercial and domestic building industry, leading to the abandonment of lumber boom towns like Jennings. The coal industry and its towns in Garrett and Allegany Counties were particularly hard hit by the Depression. Coal districts in Western Maryland like George's Creek Valley in Allegany County had been centers of labor unrest since the 1890s, when workers struck against the coal companies five times. In 1922, more than 5,000 men participated in an unsuccessful strike organized by the United Mine Workers. When the mines reopened, sixteen of the eighteen mines in Garrett County remained open-shop company towns. The precipitous decline in coal production after 1930 led to renewed union activity as workers were laid off and their families struggled to survive. Although Stryker frequently sent FSA photographers to mining communities in Pennsylvania and West Virginia, the only FSA images of Maryland mining in the file are of the remote town of Kempton, which straddled the state line with West Virginia. In fact, the post office and company store were actually in West Virginia, although the rest of the town was in Maryland. John Vachon documented the striking workers there in May of 1939, capturing the bleakness of the landscape and the people living in crowded company housing with inadequate sanitation.[3]

► Arthur Rothstein. November 1936. An automobile accident on the U.S. 40 between Hagerstown and Cumberland.
USF34 005608-E

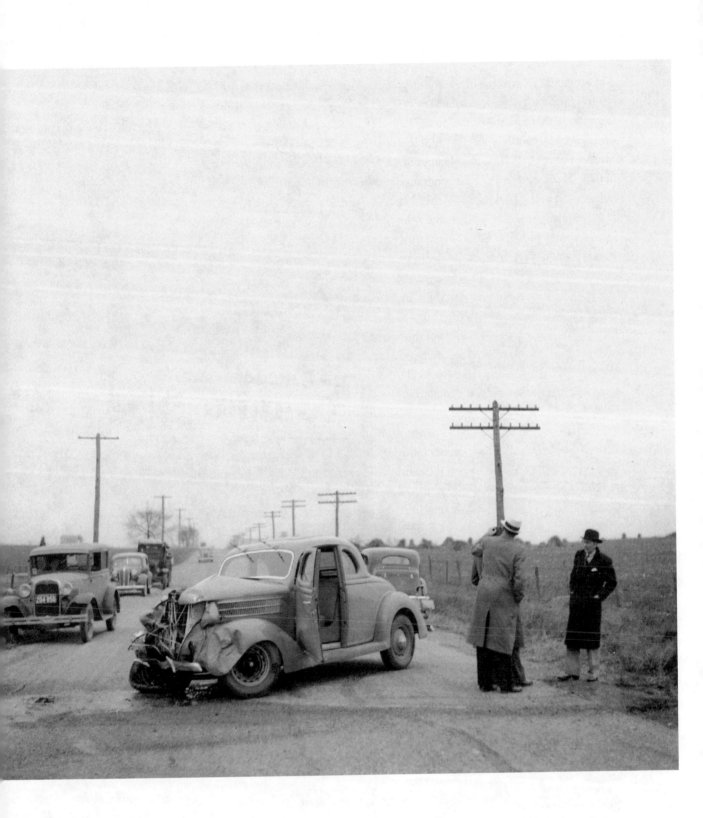

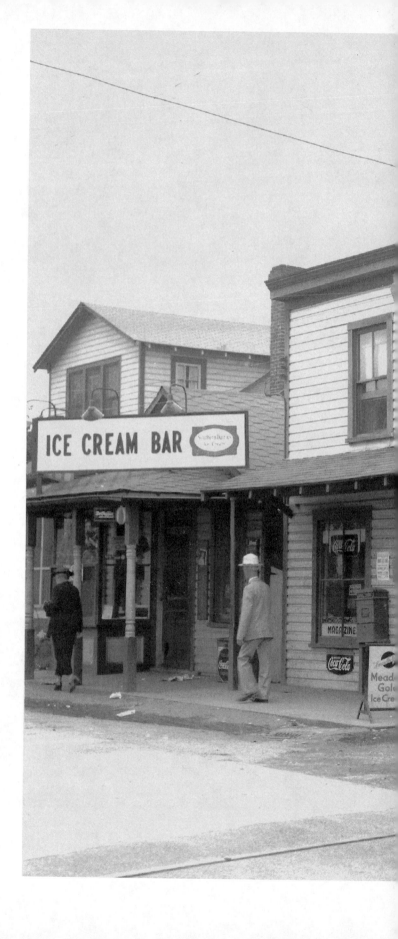

John Vachon. Berwyn,
September 1937. Post Office.
USF34 015615-D

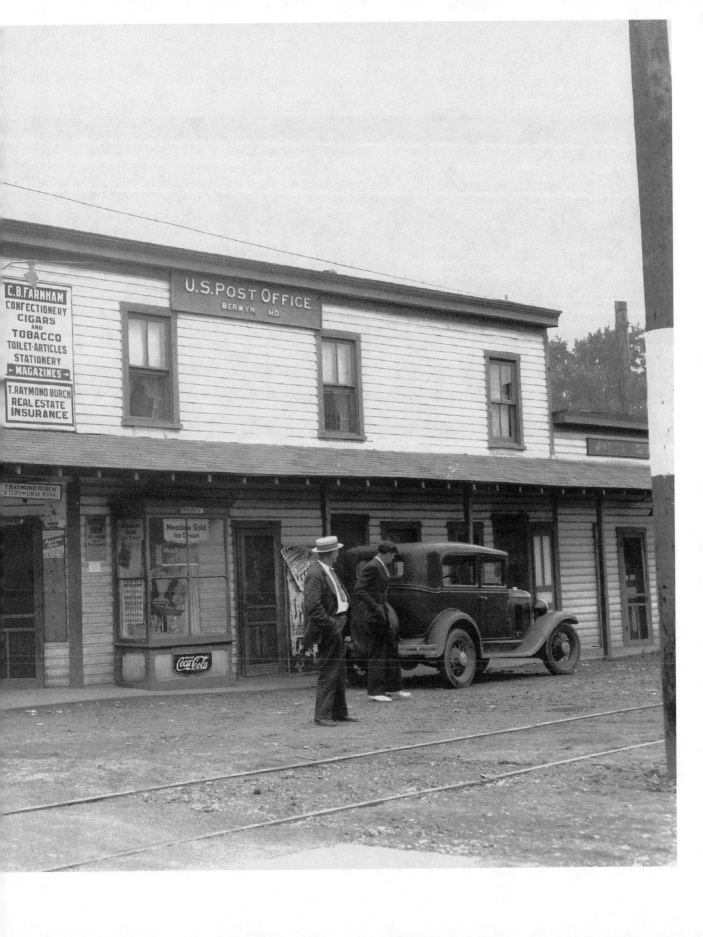

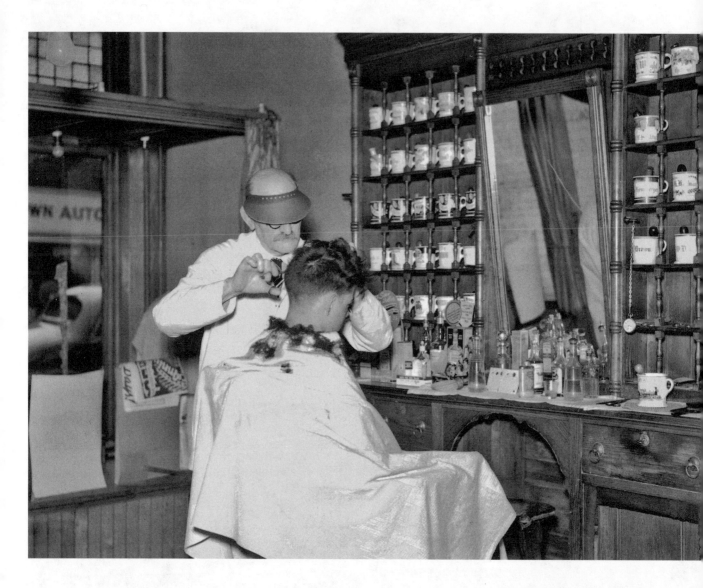

Arthur Rothstein. Hagerstown,
October 1937. A barber shop.
USF34 025982-D

► (*top*) Arthur Rothstein.
Hagerstown, October 1937.
The railroad station.
USF34 025979-C

► (*bottom*) John Vachon.
Cumberland, May 1939.
Fire Department.
USF33 001367-M1

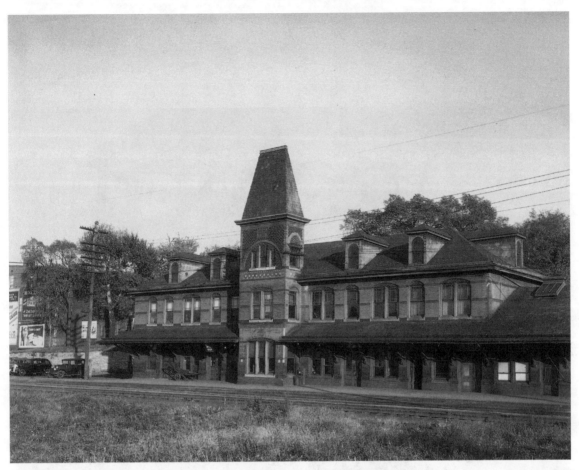

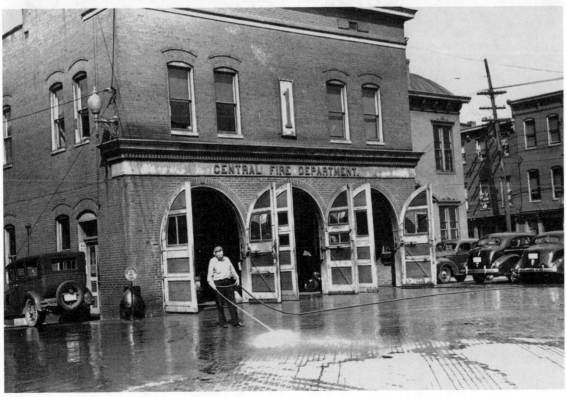

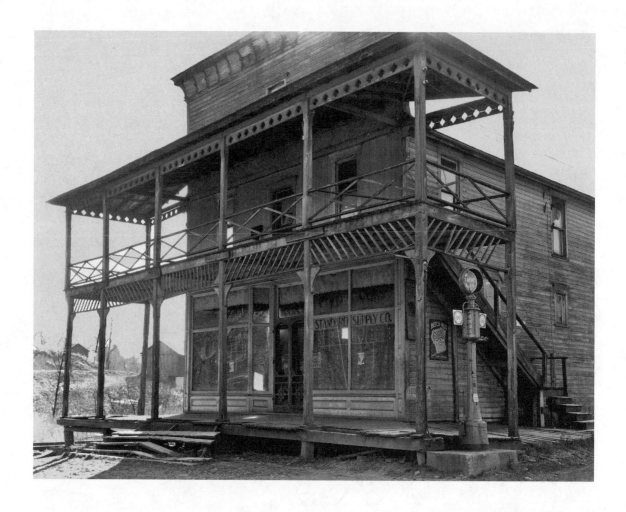

Arthur Rothstein. Jennings, December 1937. A ghost lumber town. Abandoned hotel and general store.

USF34 026068-C

───────

► John Vachon. Kempton (W.Va. and Garrett County), May 1939.

USF34 008985-E

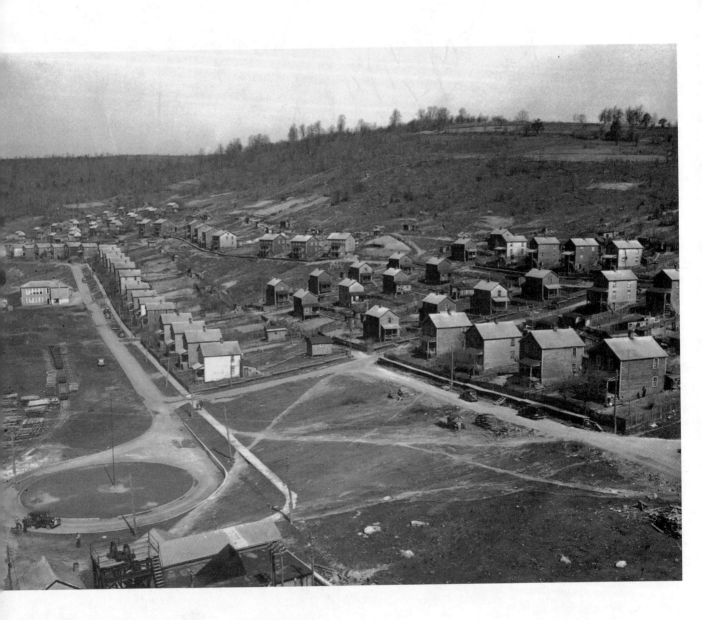

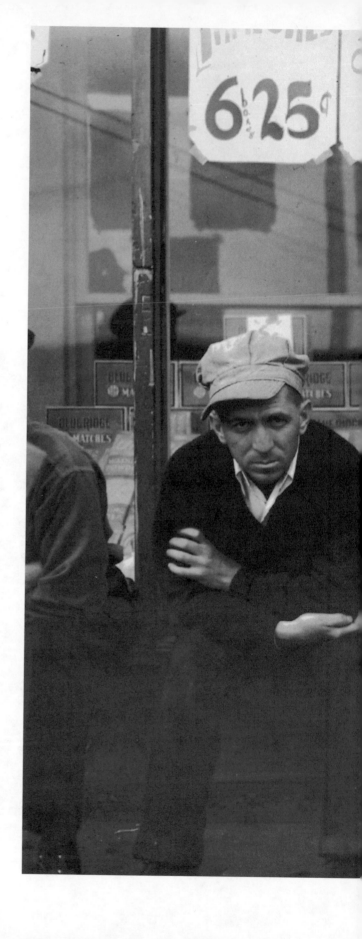

John Vachon. Kempton
(W.Va. and Garrett County),
May 1939. Striking coal miners
in front of the company store.

USF34 060001-C

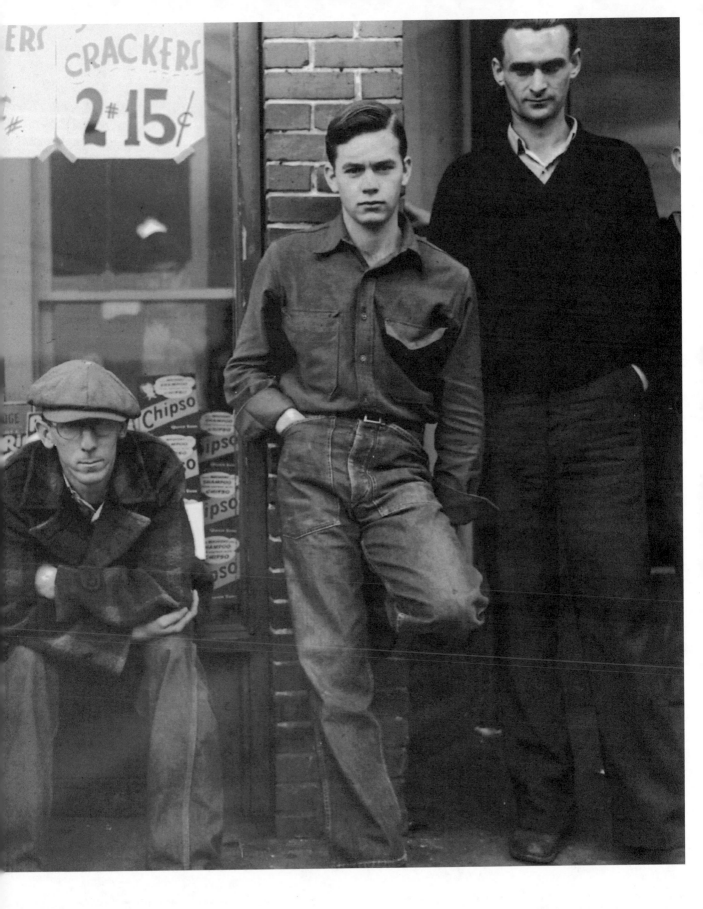

Chesapeake Bay and Tidewater

The Chesapeake Bay and the tidewater lands surrounding it historically provided Marylanders with a natural resource in seafood and "well-watered" and arable land for agriculture. During its heyday as a commercial fishing and oystering center in the last half of the nineteenth century, the bay produced rich harvests of oysters, reaching a peak of 15 million bushels in 1884–1885.[4] Regulation of the oyster harvest, going back to the law in 1865 permitting dredging only under sail, led to the development of a unique waterfront culture in Maryland and the survival through the twentieth century both of a working sailing fleet and of "hand-tonging," the oldest method of harvesting oysters.

As in agriculture, economic hard times for watermen did not start with the stock market crash in 1929 and the depression that followed. The decline of the industry had begun even before a1924 outbreak of cholera traced to contaminated raw oysters brought it nearly to a standstill. Many watermen switched from oystering to crabbing, and the crab harvest quadrupled between 1924 and the start of World War II. Nevertheless, the WPA publication *Maryland: A Guide to the Old Line State* reported at the end of the 1930s that seafood was still a $5 million industry, providing work for 10,000 people. "Oysters constitute 75 percent of the 40,000,000 pounds of shell fish taken annually from the Chesapeake Bay, crabs 24 percent, and clams a far smaller percentage."[5] The FSA photographers who visited these watermen, many of whom were African-American, captured not only the timeless beauty of their surroundings and the rhythms of their work, but the hardships of poverty and the realities of segregation and racism.

John Vachon. Annapolis, November 1937. Farmers hanging around the market.

USF33 001000-M2

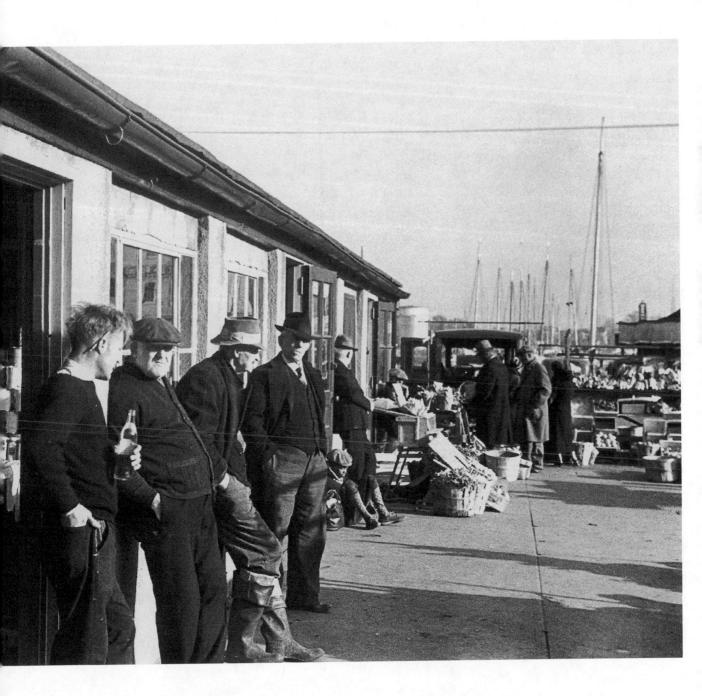

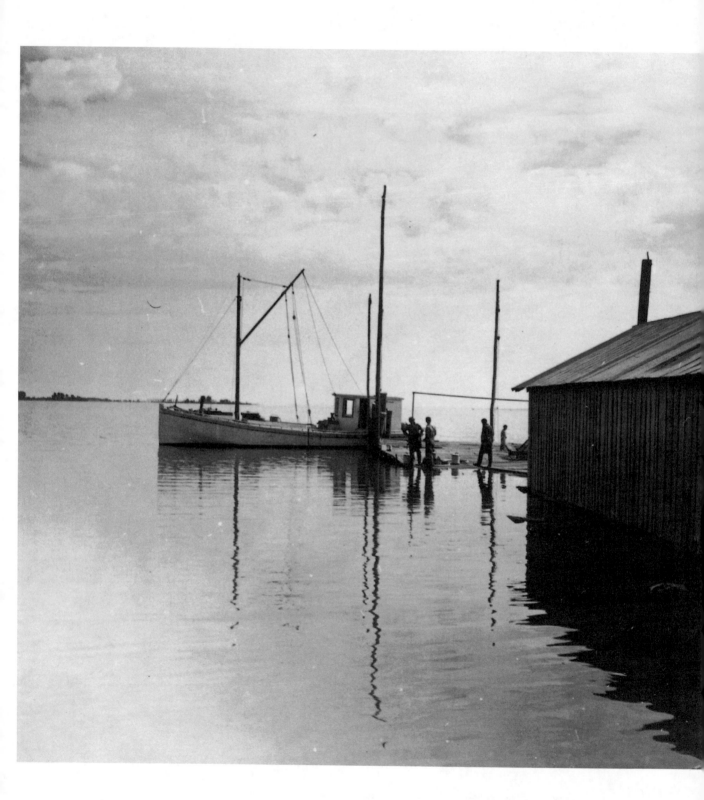

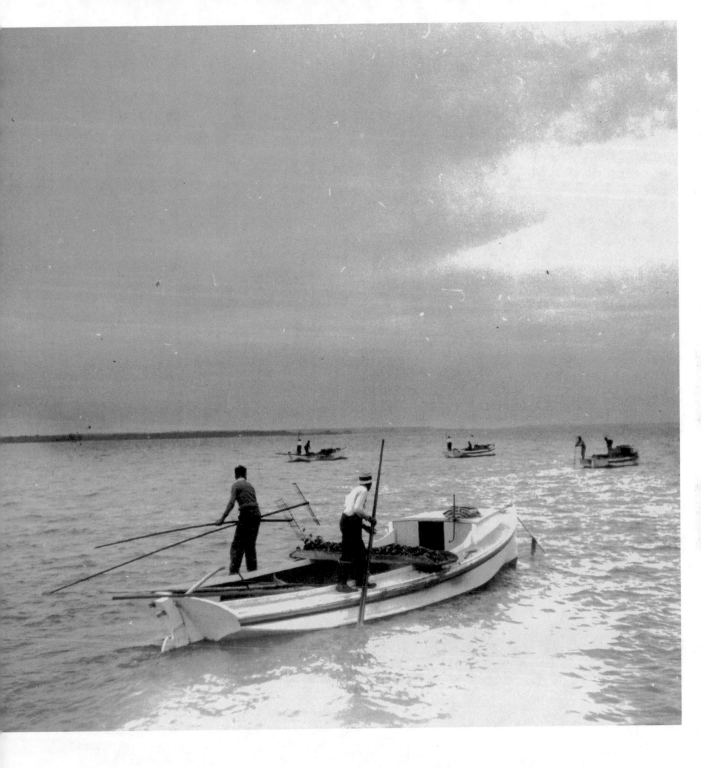

◄ Arthur Rothstein. Rock
Point, September 1936.
At the wharf.
USF34 005432-E

Arthur Rothstein. Rock
Point, September 1936.
Working an oyster bed.
USF34 005433-E

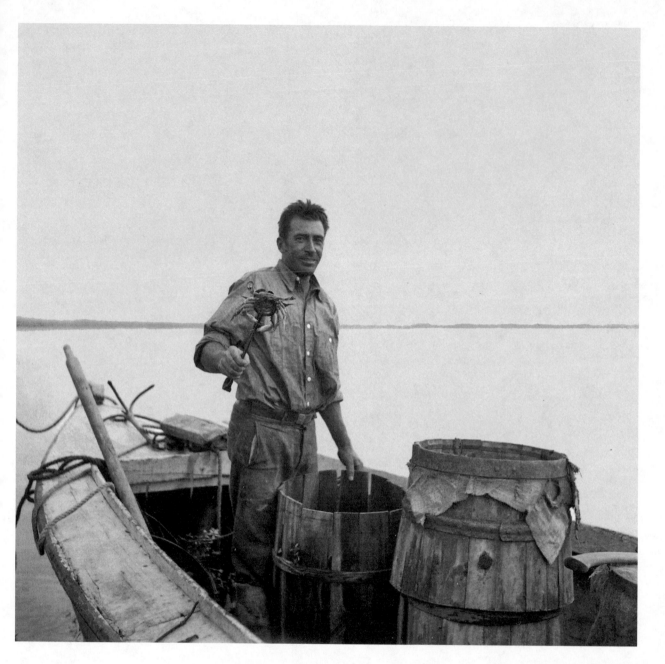

Arthur Rothstein. Rock Point, September 1936. Crab fisherman.

USF34 005430-E

► John Collier, Jr. Dorchester County, January 1942. Shanties of Negro "watermen" families, Gibson Island. *[Author's Note: Although Collier located the scene in Dorchester County in his caption, Gibson Island is actually in Anne Arundel County.]*

USF34 082196-E

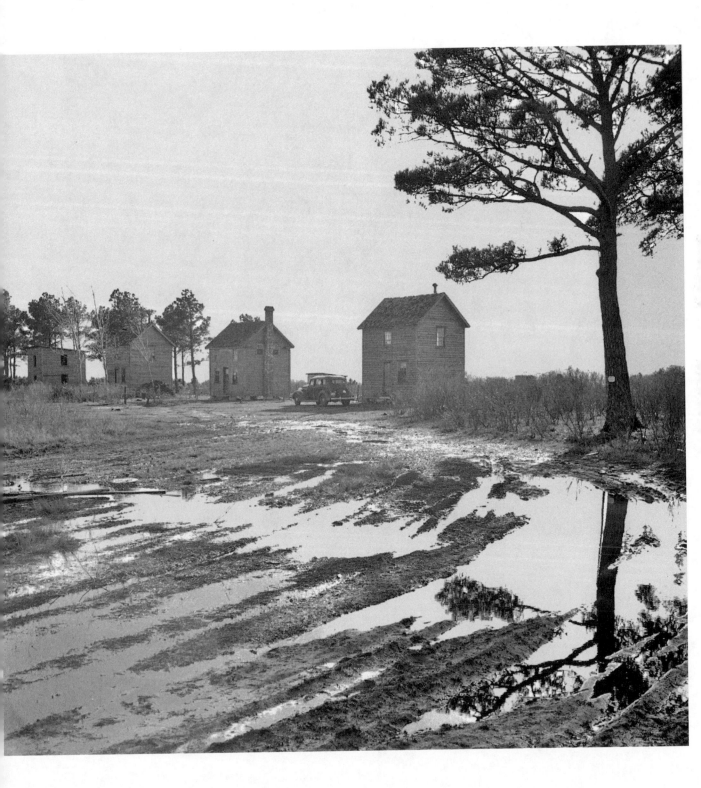

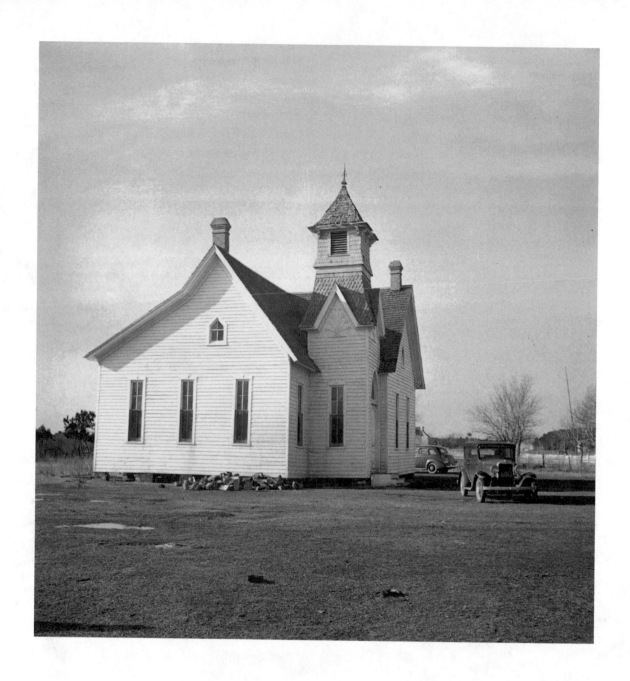

John Collier, Jr. Dorchester
County, January 1942. The
congregation of this church
are all "watermen"; oystermen,
lobstermen, fishermen. Only
a few raise anything on the
soil and they all look to the
Chesapeake Bay for their main
source of livelihood.

USF34 082190-E

Eastern Shore Agriculture and Industry

The development of the hermetically sealed canning process for mass production and national marketing of oysters in the late nineteenth century had an important side benefit for Maryland's Eastern Shore in the parallel development of a major vegetable canning industry. At the turn of the century, canning was the third most important industry in the state, and its seasonal labor force was reported in 1907 to be 20,000 workers: in the fields picking tomatoes and beans and cutting corn; in the packing houses preparing vegetables for sealing in tin cans; in the warehouses packing into cases the labeled finished product.[6] This industry too faced serious decline during the 1920s and 1930s. Vegetable farming continued, but improved transportation diverted some of the crop to larger canning operations in major urban centers.

Nevertheless, canning, particularly of tomatoes, remained a major part of the Eastern Shore economy. The WPA *Maryland Guide* published in 1940 reported that farmers in Dorchester County alone grew over 10,000 acres of tomatoes. The largest and most prominent of the canneries was that of Cambridge's Phillips Packing Company, organized by Albanus Phillips in 1899. In the 1920s he marketed his canned tomatoes all over the United States, but actively resisted all efforts of his workers to organize for better wages and conditions. More than 2,000 striking workers clashed with Phillips in the streets of Cambridge during 1937 as wages remained low and he refused to negotiate. Strikers overturned nineteen Phillips trucks before the Maryland state labor commissioner arrived to negotiate a temporary truce to end the violence. The National Labor Relations Board eventually intervened, but not until World War II were the Phillips canneries unionized.[7]

Throughout the 1930s, migrant workers performed much of the unskilled labor of the canneries as they made their way north along the east coast. Growers and packers provided minimal housing for these laborers. From the beginning of the Historical Section's work, its photographers showed interest in the plight of these migrant workers, capturing images from California to Florida of their long hours, backbreaking labor, and substandard housing. Jack Delano's sympathetic photographs of workers at the Phillips plant in 1940 continued in this tradition. The photographs also portray graphically the distinctions between the living conditions and work of black migrant workers and local white employees who worked for the canneries.

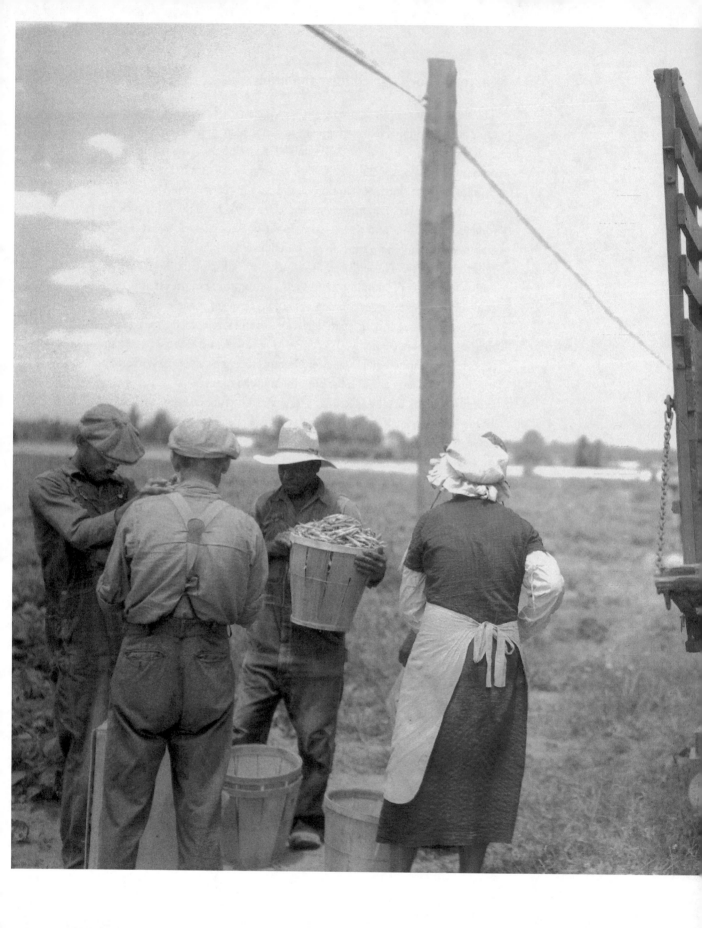

Arthur Rothstein. Cambridge
(vicinity), June 1937. Loading
a truck with string beans.

USF34 025597-D

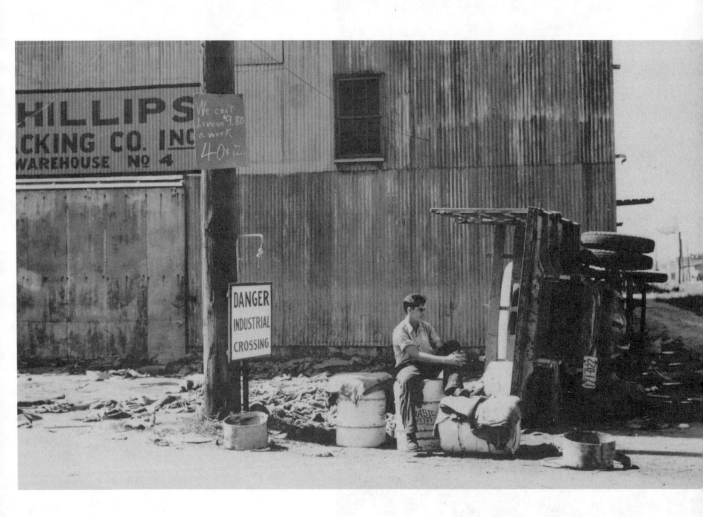

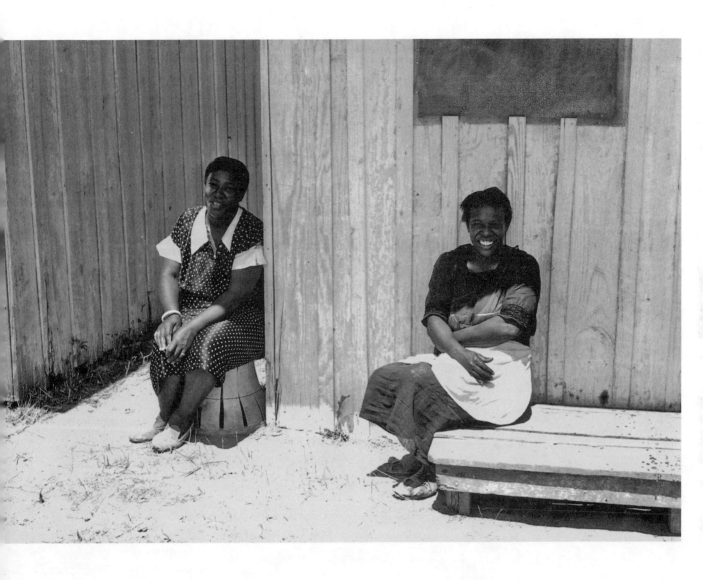

Jack Delano. Vienna, July 1940.
Two migratory workers at a
camp on a Sunday afternoon.
USF34 040918-D

◄ Arthur Rothstein. Cambridge,
June 1937. Strike at the
Phillips Packing Company.
USF34 025586-D

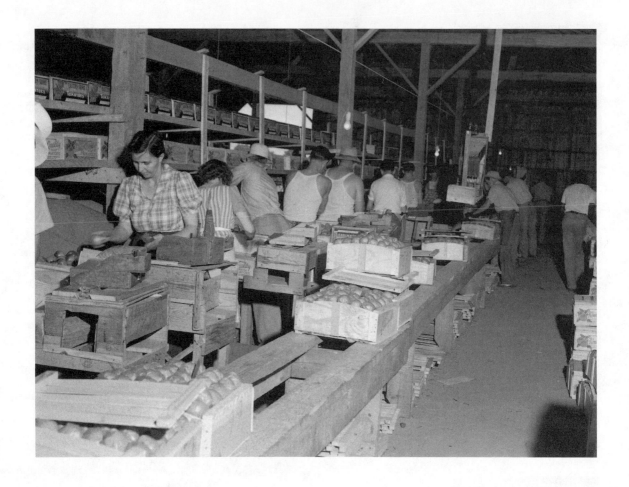

Jack Delano. Kings Creek,
July 1940. Wrapping tomatoes
in the Kings Creek Packing
Company. The wrappers are
usually from Florida, are
highly skilled, and seem to
be well paid.

USF34 040893-D

► John Collier, Jr. Cambridge,
August 1941. After the
cans have been filled with
tomato juice and sealed,
metal baskets carry
them to a chilled water
pool for cooling at the
Phillips Packing Company.

USF34 080662-C

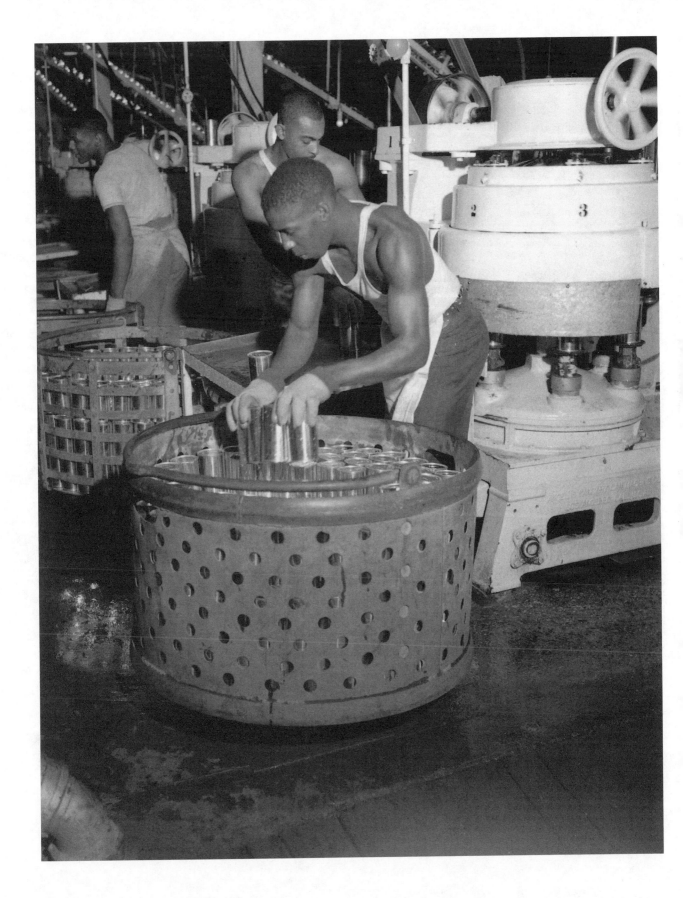

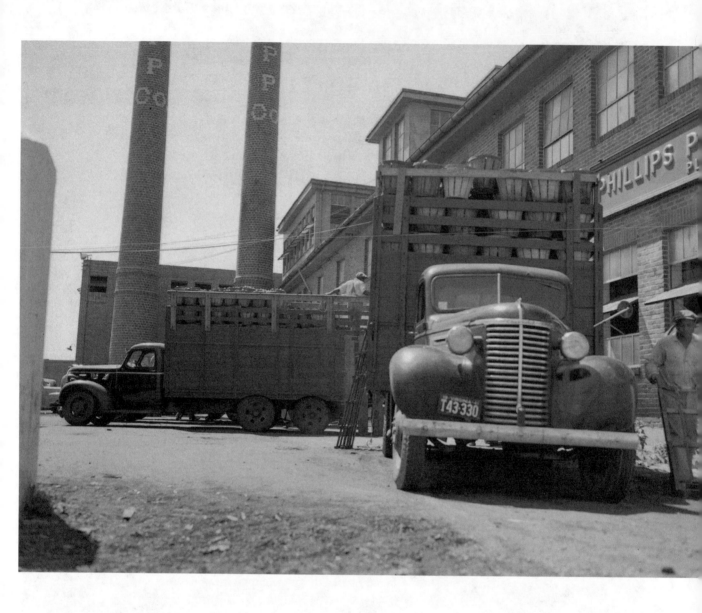

John Collier, Jr. Cambridge,
August 1941. Trucks unloading
tomatoes directly into the
canning room of the Phillips
Packing Company.

USF34 080691-C

Southern Maryland Agriculture and the Faces of Poverty

Southern Maryland's staple crop from the earliest days of settlement was tobacco, with corn an important supplemental crop for food. When enslaved African-Americans achieved freedom at the end of the Civil War, many freedmen remained on the land, some as tenant farmers, a few gaining ownership of their own land. Tenants and small landholders continued to cultivate corn and tobacco in much the same way as had their ancestors. After centuries of intensive farming, the soil they tilled was generally exhausted or eroded. During the 1930s much of Southern Maryland was overwhelmingly black, rural, and impoverished. Many lived in the homes their enslaved or newly freed grandparents had built near the old plantation house. Public health issues abounded; they drew water from shallow and unsanitary wells, used outdoor privies, and went unprotected from mosquito-borne diseases because of unscreened doors and windows. After Resettlement Administration plans for relocating the poorest of the poor off the land had been abandoned, the Farm Security Administration initiated a variety of programs to solve these problems that impacted health and everyday survival. FSA local agents provided loans to farmers to form cooperatives to purchase needed equipment, demonstrated safe canning techniques, and showed sharecroppers and their families how to dig a sanitary well or build a screen door.

Regional administrators, seeking illustrations for their reports, often asked Stryker to send photographers to document the work of these FSA local agents. Although responding to such requests was the bread and butter of the agency's workload, the photographers generally disliked such routine assignments. Marion Post Wolcott and John Collier, Jr., spent several hot days in Charles County in July of 1941 documenting step by step the digging of a well (140 photographs) and the building of a screen door (60 photographs.) Readers of this book have been spared these images, although those interested can see all of them at the Library of Congress Prints and Photographs Division website. But such assignments offered the photographers opportunities to seek out and photograph for the file the way people lived in Southern Maryland. Their photographs of a one-room schoolhouse, the rural post office, and the faces of the children of FSA clients document dramatically the poverty of the region, but they also have a haunting, poignant beauty and reflect the dignity and good humor of a people for whom much would soon change. Wartime industrial work lured many off the land; postwar economic prosperity provided opportunities for others in the growing suburbs of Princes George's County and Baltimore.[8]

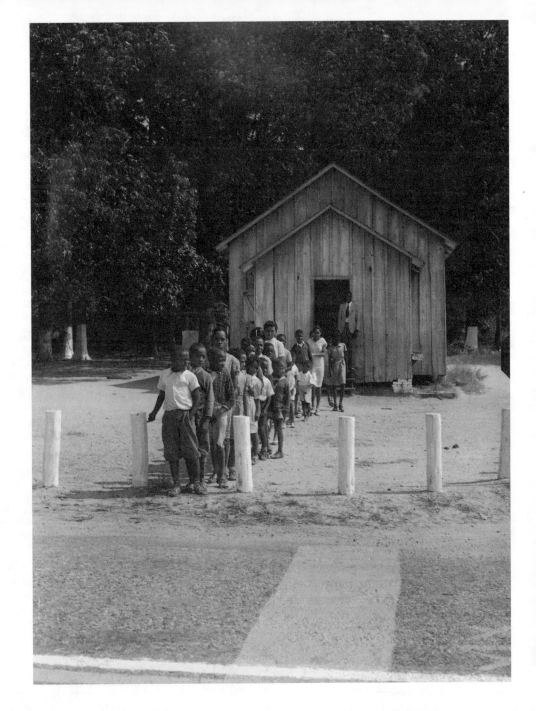

John Vachon. St. Mary's
County, September 1940.
Children coming out
of school at noon.

USF34 061367-D

◄ Russell Lee. Tompkinsville,
1939. Post office.

USF34 035083-D

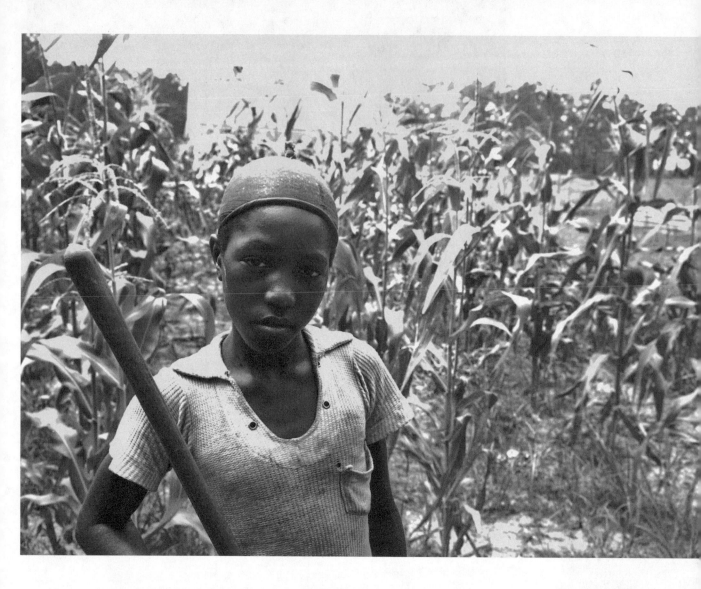

Jack Delano. Scotland,
St. Mary's County, August 1940.
One of the children of FSA
client Harry Handy. The plot
of corn, as well as the rest
of their garden, was provided
by FSA aid.

USF34 041012-D

► (*top*) John Vachon. St. Mary's
County, September 1940. Mrs.
Eugene Smith, an FSA client,
canning string beans.

USF34 061402-D

► (*bottom*) John Collier, Jr.
St. Mary's or Charles County,
July 1941. Negro supervisor
explaining the health hazard
of a shallow well to a Farm
Security Administration
borrower's family.

USF34 080048-D

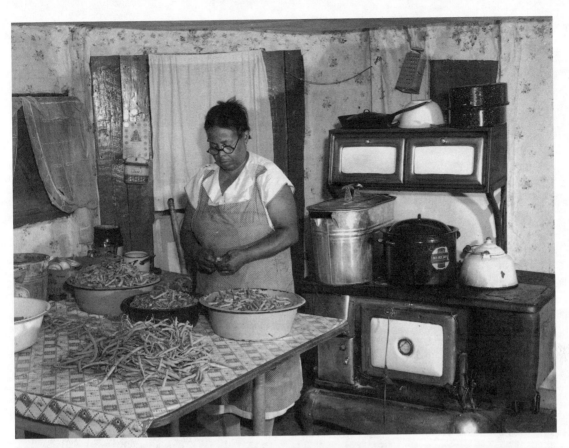

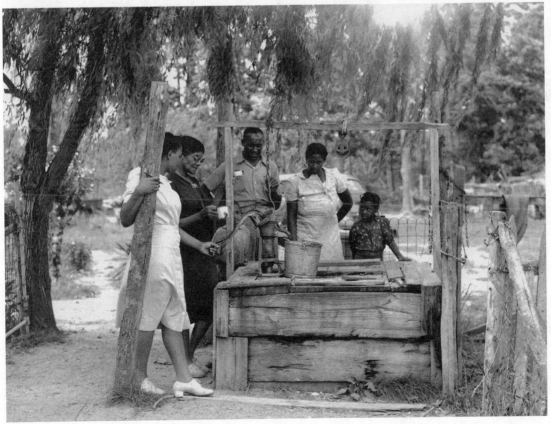

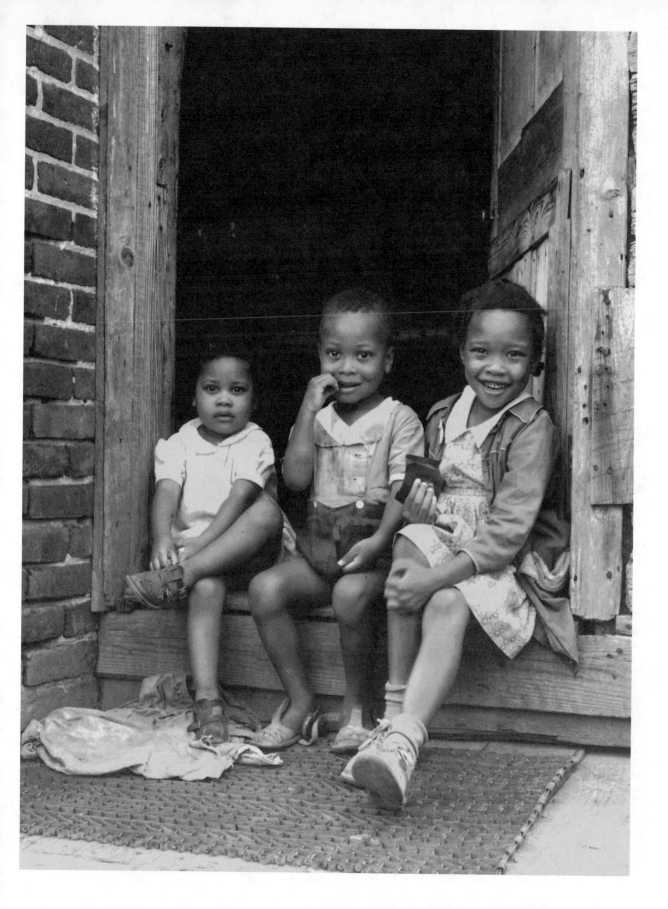

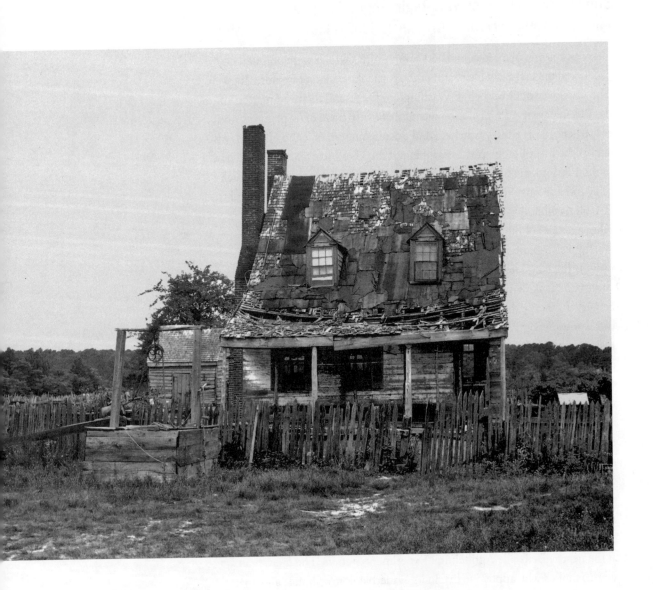

John Collier, Jr. Ridge (vicinity), St. Mary's County, July 1941. Fourth generation from slavery. Grandfather Briscoe's great grandchildren who live in John Briscoe's farmhouse, which was built before the Civil War.

USF34 080063-D

John Collier, Jr. Ridge (vicinity), St. Mary's County, July 1941. Plantation house built before the Civil War which is now owned and lived in by John Briscoe, a descendant of slaves.

USF34 080062-D

Suburb, City, and Highway: Beginnings of the Eastern Metropolitan Corridor | Greenbelt, 1935–1939

Greenbelt is one of three completed communities which were uniquely a product of the first New Deal, and of the particular vision of Rexford Tugwell. The proximity of Greenbelt to Washington, D.C., and the headquarters of the Resettlement Administration meant that every stage of its planning and construction was closely watched, and documentation of its beginnings was almost the first photography assignment of the Historical Section of the newly formed Resettlement Administration (RA). The Suburban Division which built and administered this new town was the only wholly new project of the RA; all its other divisions had been transferred to the RA from projects in other agencies of the first New Deal.

Tugwell's grand idea was one of a series of planned communities to provide housing for poor and working-class urban families in the healthier suburban outskirts of large cities, away from rundown or blighted urban centers. In theory their departure would enable later projects to regenerate those now-depopulated city centers. In the new suburban communities, residents would live cooperatively in neighborhood units surrounded by gardens and green spaces. With pedestrian and automobile traffic separated, children could walk to schools and libraries and their parents could walk to stores and shops.[9]

The original Greenbelt community consisted of 885 units, built thirteen miles northeast of Washington, D.C., in Prince George's County, until then predominantly rural. Its construction became a source of work for thousands of unemployed laborers who flocked from nearby urban areas. That work remained strictly segregated; one photograph (not reproduced here) shows African-Americans seeking work being directed into segregated employment lines for "colored." Greenbelt's residential units provided homes for workers at the nearby Beltsville Agricultural Experiment Station. The more than 5,700 white families who applied to live in its cinderblock townhouse and apartment units filled out detailed questionnaires. To ensure that applicants would participate in the cooperative nature of the new community, families were carefully interviewed before the first tenants moved into their new homes in September 1937. In addition to identifying families "willing to cooperate and participate" in this social experiment in community living, the complicated selection process imposed an income restriction (to ensure that low-income families would receive preference), limited family size to no more than six (because of the relatively small size of the units), and established quotas for the District of Columbia, Maryland, and Virginia so that the new community would be a cross section of the greater Washington, D.C., area.[10] Wartime

demands for housing for defense workers led to the construction of an additional thousand units adjacent to the original five "superblocks" in 1941.

From the beginning, despite local criticism, Greenbelt drew visitors by the thousands—the *Washington Post* reported "more than 350,000" had come by March 1937, among them senior members of the Roosevelt administration. These visits provided opportunities for the Historical Section to create public relations images for the RA, highlighting the success of its innovative policies. Carl Mydans, in his initial assignment in November 1935 shortly after ground was broken at Greenbelt, photographed Roy Stryker and his boss, John "Jay" Carter. Carter was a close confidante of Roosevelt's, undersecretary of agriculture from 1934 to 1936, and destined to become special research assistant to Tugwell in the RA in March 1936. A year later, in November of 1936, Arthur Rothstein photographed Tugwell showing President Roosevelt the progress that had been made at Greenbelt.

Like many other New Deal programs designed to provide jobs, much of the work was done by manual labor. Its planners designed everything from simple furniture built to the scale of the compact room layout of the individual homes to the modern artwork that adorned the exterior facades of community buildings. Although the state provided public schools, residents formed cooperatives to provide other needed services, from grocery stores to gas stations to medical clinics.[11]

Carl M. Mydans. Greenbelt, November 1935. A model community planned by the Suburban resettlement division of the U.S. Resettlement administration. John Carter, Roy Stryker, and Major Lewis, of the Resettlement Administration, at the project.

USF33 000269-M1

► Arthur Rothstein. Greenbelt, November 1936. President Roosevelt and Dr. Tugwell on an official inspection.

USF33 005628-E

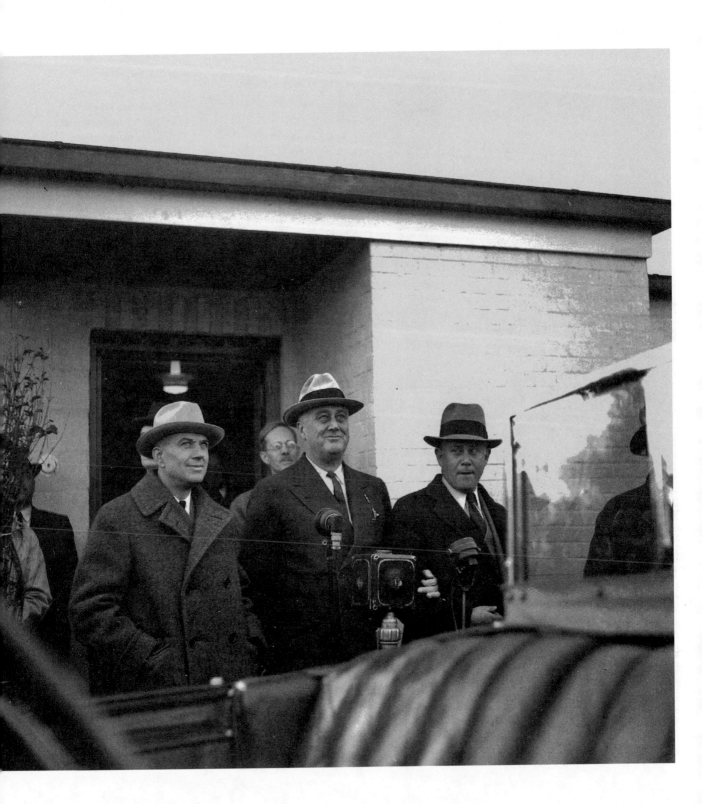

► Carl M. Mydans. Greenbelt, July 1936. Making cinder blocks for use in building a model community planned by the Suburban division of the U.S. Resettlement administration.

USF33 000638-M3

Carl M. Mydans. Greenbelt, July 1936. A model community planned by the Suburban division of the U.S. Resettlement administration. Laborers.

USF33 000642-M3

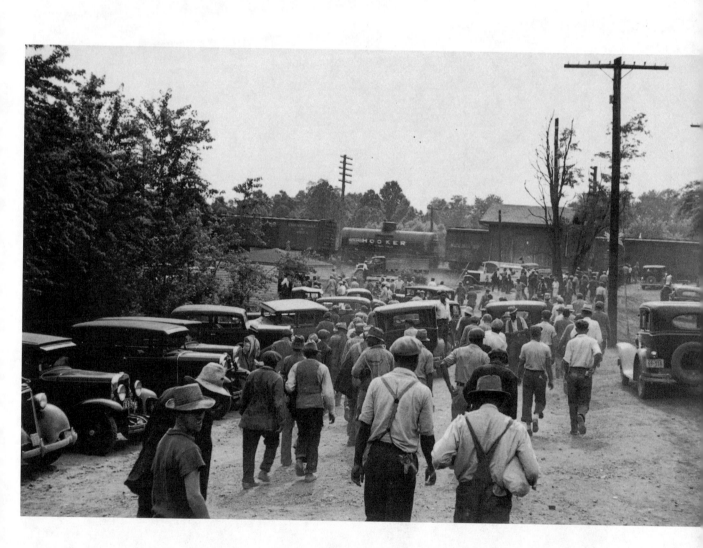

John Vachon. Greenbelt,
November 1937. A school room.
USF33 001028-M2

◄ Arthur Rothstein. Greenbelt,
July 1937. Community building.
USF341 025686-B

Marion Post Wolcott.
Greenbelt, September 1938.
Cooperative gas station.
USF33 030020-M5

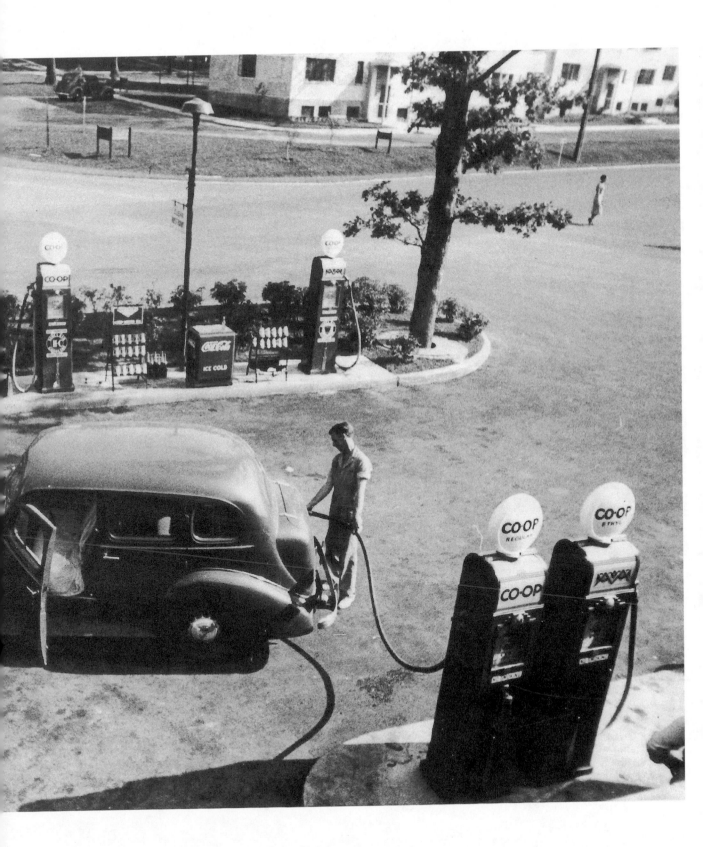

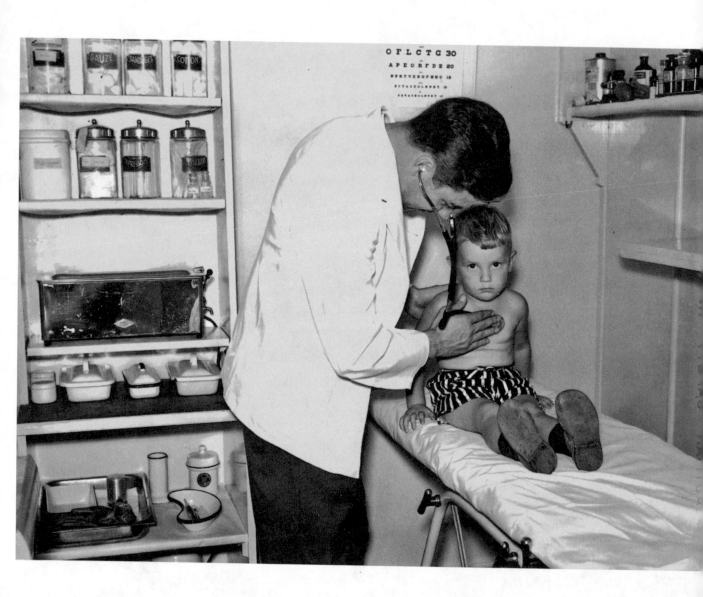

Marion Post Wolcott.
Greenbelt, August 1939.
Examining a child
in the medical center.

USF34 052037-D

Baltimore, 1938–1939

BALTIMORE (804,874 pop.) proud, self-sufficient, sits beside the Patapsco River, looking nostalgically to the South but turning to the North for what it takes to make a bank account grow. Midway between the North and South, . . . it is even today a city of violent contradictions. . . . Baltimore embraces within its capacious borders the grave of Edgar Allan Poe and the center of the straw hat industry; it manufactures steel ships, and steel rings to protect their wearers from rheumatism; it cans more food than any other city in America. . . . City of rarified aristocrats and often rowdy intellectuals, of dismal slums and spacious mansions, of the insistent odor of fertilizer and the delicate bouquet of the Cardinal's crocuses, of cobblestones and gas lights and monuments; gazing wistfully upon the old, suspiciously upon the new, and benevolently upon the rest of the country, . . . it is charmingly picturesque in its ugliness. Red brick houses, row on row, with scrubbed white steps, line the narrow streets of the old town; yellow brick houses, miles of them, run uphill and down; . . . lordly mansions of the rich preen themselves in groves and parks in the smart suburbs to the north along Charles Street Avenue Extended.

— *Maryland, A Guide to the Old Line State*
(New York: Oxford University Press, 1940), 196–97

When Roy Stryker began assigning the Farm Security Administration photographers to work in Baltimore in July of 1938, it had begun to revive from the worst economic crises of the Depression. Primarily because of the outbreak of war and rearmament of Europe and Asia, Baltimore experienced an expansion of its most powerful economic engines: the steel, aircraft, and the shipbuilding industries. Japan had become Bethlehem Steel's biggest customer by 1937: the *Baltimore Sun* quipped in February of that year that the junkman collecting scrap iron in Baltimore's alleys was "doing his bit for the Japanese war effort."[12] By 1939 the British government had placed orders for $70 million worth of new aircraft with the Glenn L. Martin Company. The port of Baltimore, with its twenty-five miles of waterfront, had risen to sixth in size in the world, and was poised once again to become the shipping center for a massive war effort.

Despite these signs of recovery, however, poverty remained in 1938; even expanding industrial employment had not yet overcome the 22 percent unemployment rate that taxed the city's resources during the depths of the Depression. Home ownership declined by one fifth between 1930 and 1939 as a result of mortgage foreclosures which forced families out of their houses.[13] Baltimore's African-American population, 142,000 in 1940, had been particularly hard hit by the economic crises of the 1930s, and the black business district con-

centrated along Pennsylvania Avenue in the northwest section of the city still showed signs of economic distress.

Arthur Rothstein and John Vachon were experienced members of the FSA staff, but Sheldon Dick had only joined the Historical Section in May of 1938. The reality of continued poverty is absent from many of the fifty photographs they took for the FSA/OWI file of Depression-era Baltimore. Instead they confirm the city's historic self-image of a proud and successful port with its sheltered inner harbor and long streets of rowhouses as far as the eye could see with well-fed housewives scrubbing their white marble steps. But other images, particularly those taken by Sheldon Dick, look beyond the façade of the city's elegant mansions, portraying unemployed black men and dirty-faced white children in "the slum district." Baltimore's return to prosperity and the beginnings of its eventual transformation into the modern city of today, fueled by the full economic impact of a sustained war effort, was still a year or two away in 1938.

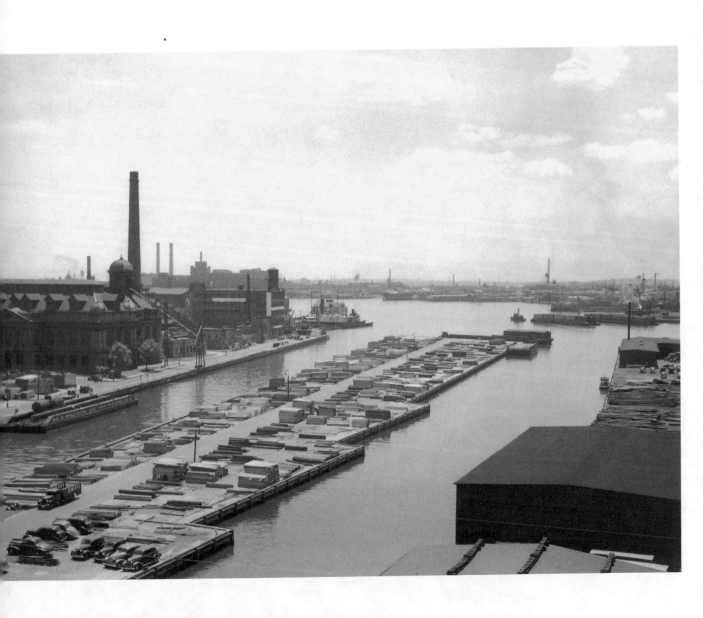

Arthur Rothstein. Baltimore,
June 1938. Waterfront.

Sheldon Dick. Baltimore,
July 1938. Scrubbing
white steps.
USF33 020025-M2

► Sheldon Dick. Baltimore,
July 1938. Negro district.
USF33 020019-M5

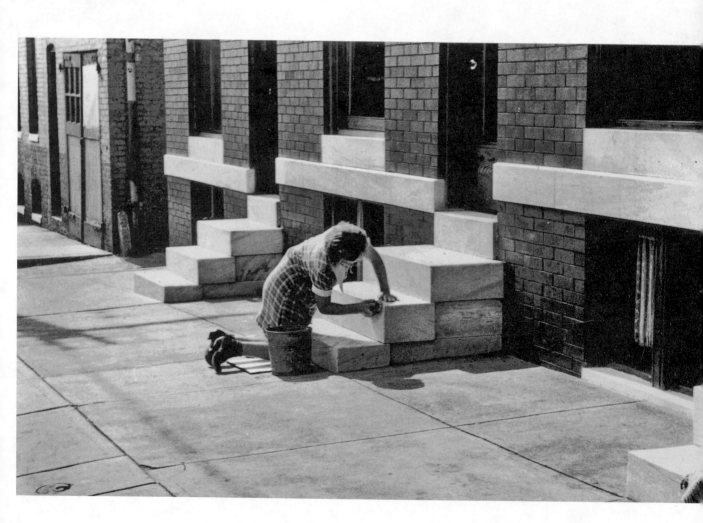

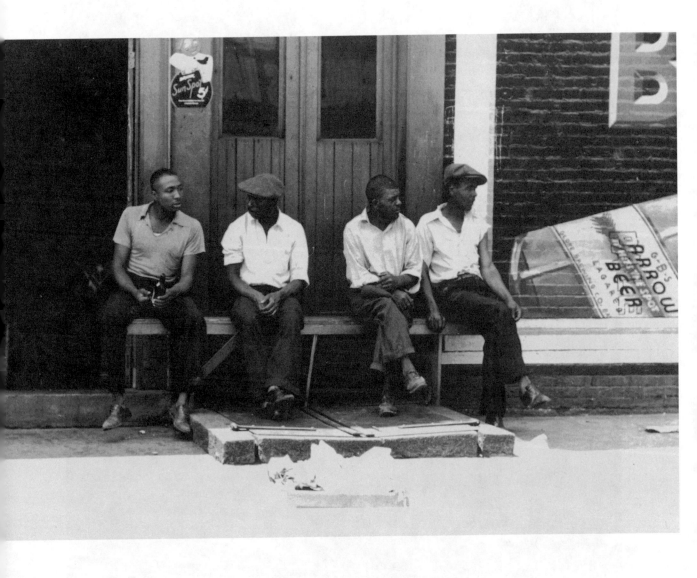

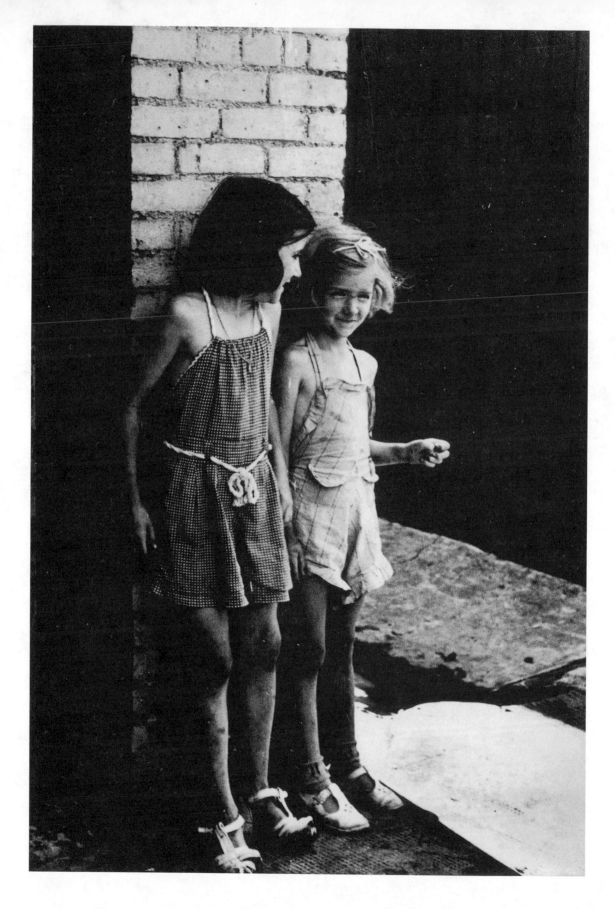

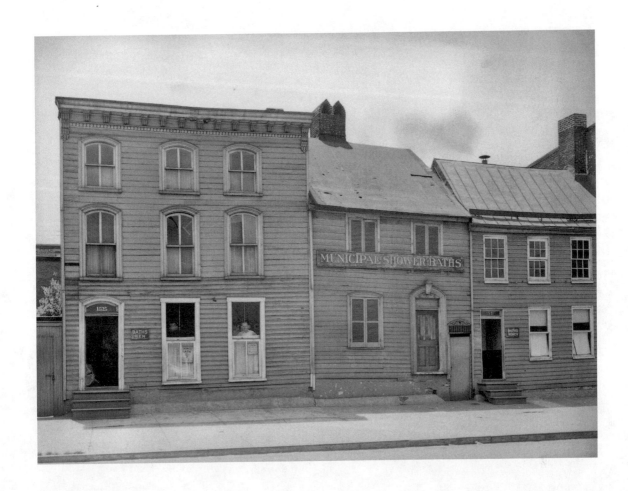

John Vachon. Baltimore,
July 1938. Municipal baths.

◄ Sheldon Dick. Baltimore,
July 1938. Children
in the slum district.

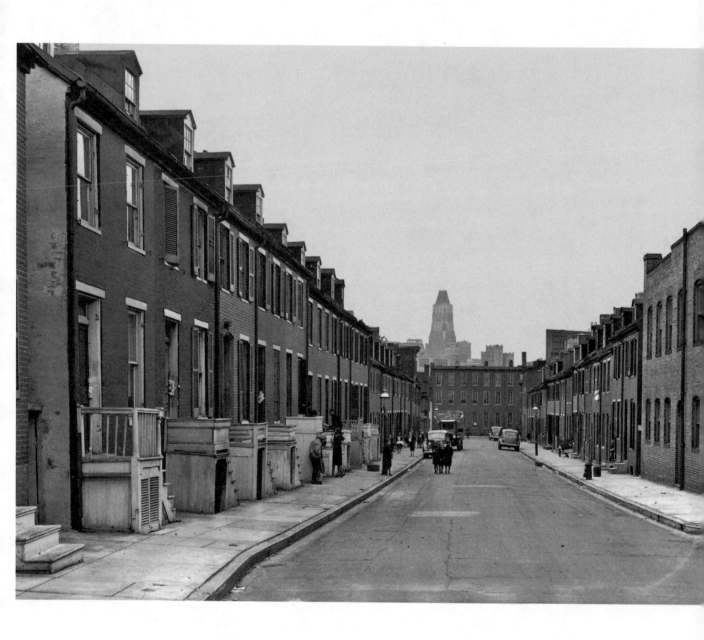

Arthur Rothstein. Baltimore,
April 1939. Row houses.

USF34 027174-D

Route 1 in 1940

Highway 1, originally the Old Post Road between Philadelphia and Baltimore, by 1940 had become a major artery connecting the states along the eastern seaboard from Florida to Maine. It was part of a large and growing system of state and national highways in Maryland. When the Maryland WPA *Guide* was published in 1940, Maryland boasted a total road structure of 17,000 miles of hard-surfaced roads, nearly 3,000 of which were maintained by the state. The state had spent nearly $160 million to construct that system, which the State Roads Commission, created in 1908, claimed was the best in the nation, with "no farm of Maryland . . . more than two miles from a hard-surfaced road." Not only did nearly 300,000 registered automobiles use those roads, so too did forty bus lines, carrying passengers throughout the state, and a growing volume of truck freight traffic, estimated at more than 300 million vehicle miles on state roads alone in 1940.[14]

The State Roads Commission's boast that this system was the "best in the nation" faced a severe challenge from wartime growth. In the ten years after 1937, traffic counts along the portion of U.S. Route 1 that linked the industry of Baltimore to the national capitol in Washington increased more than 150 percent, and it became known by those who had to drive on it as "a highly dangerous route in spite of its width."[15] On assignment in July of 1940, Jack Delano captured with his camera the heavy traffic, the roadside signs, the tourist cabins and restaurants, and other less-welcome roadside "attractions." Taken at a time when Route 1 was already a major corridor for movement of goods and people connected with defense preparations, his photographs document vividly the concerns of the 1935 State Planning Commission that while most of Maryland's secondary country roads had been paved, its primary highway system was totally inadequate.

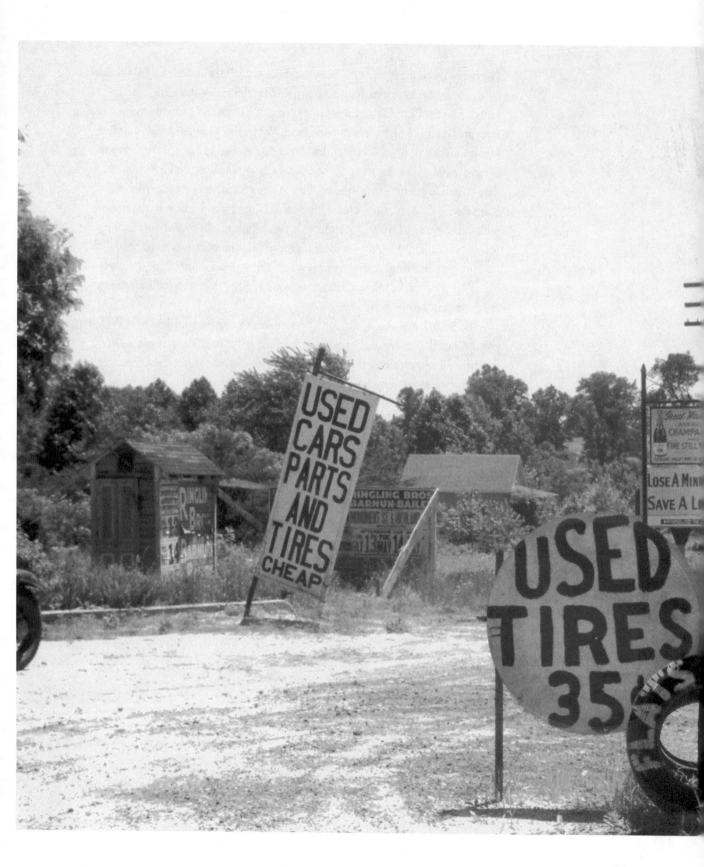

Jack Delano. Washington, D.C.
(vicinity), June 1940. U.S.
Highway No. 1, in Maryland.

USF33 020672-M3

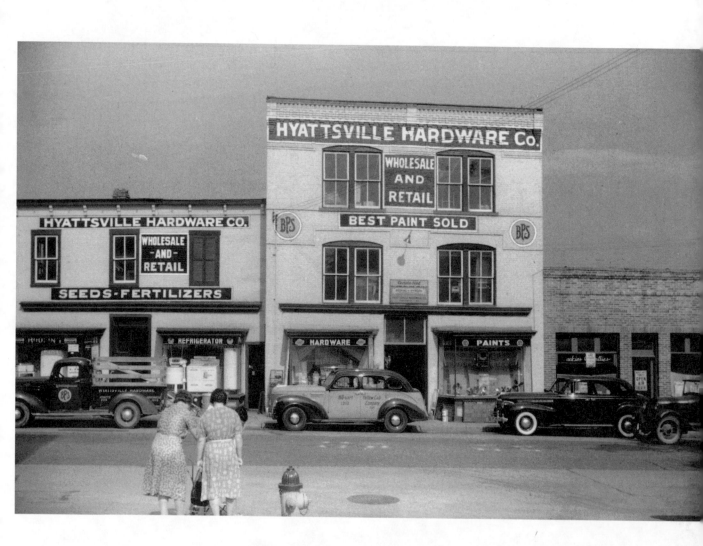

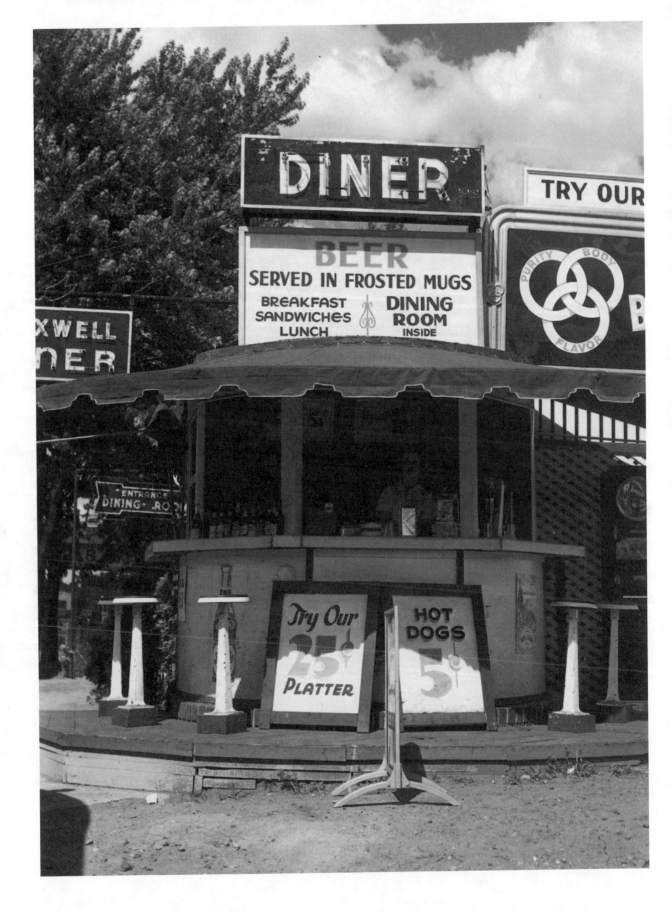

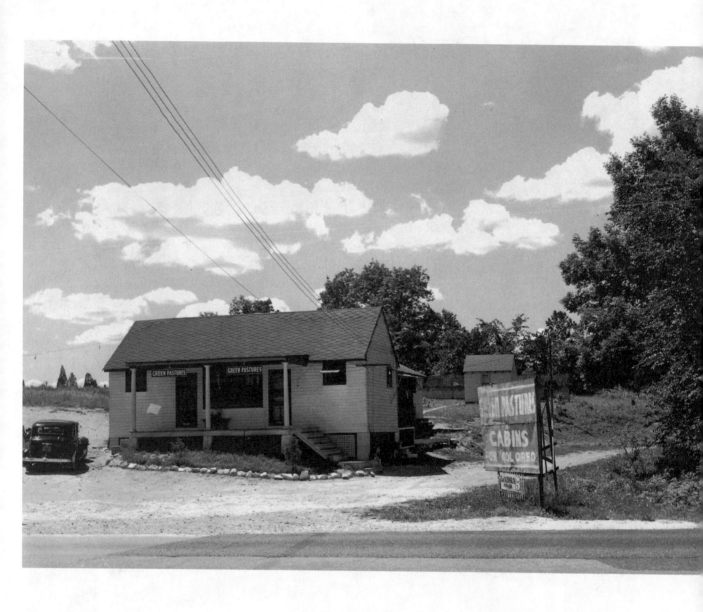

◄ Jack Delano. Waterloo
(vicinity), June 1940.
Colored tourist cabins along
U.S. Highway No. 1.

USF34 040781-D

Jack Delano. Baltimore
(vicinity), June [1940].
Used parts lot along U.S.
Highway No. 1.

USF34 040741-D

Good Times in Hard Times—Recreation and Leisure

Despite the economic hardships of the Depression, Marylanders continued to seek out and enjoy many of their traditional recreational pastimes. After 1936, Stryker developed shooting scripts to encourage his photographers to think about all aspects of life in the towns and communities they visited; his outline of possible topics to explore with a camera included questions about social activities and what people did for entertainment.[16] In response, FSA photographers pointed their cameras at such community activities as picnicking, organized sporting events, and Fourth of July community competitions. The images here are a sampling of the range of those activities. When John Vachon photographed the backsides of spectators at the Columbia-Navy game in Annapolis in November of 1937, he was not yet an "official" FSA photographer; images he took the same day of a smiling young lady in an open car and of a crowded parking lot outside the stadium suggest that he had taken one of the section's cameras along on a date. In contrast, Ben Shahn's photograph at almost the exact moment that a competitor in the Maryland state sport of jousting speared his ring with a lance is part of a series on which he was sent on assignment.

The streetcar in front of Glen Echo amusement park in 1939 brought residents of the nation's capital and Marylanders from the Washington suburbs to the outskirts of town for a day's outing. Glen Echo was originally built in 1889 as a "Chautauqua," but in 1903 the Capitol Traction Trolley Company bought it and developed an amusement park. From the 1930s through the 1950s, Glen Echo was famed throughout the region for its enormous swimming pool. During World War II the trolley company transported servicemen on leave and their dates to the pleasures of Glen Echo. Jack Delano's series of photographs of the town of Salisbury celebrating the Fourth of July in 1940 with picnics, beauty contests, a soap box derby, boating races, and a baseball game capture a community at play. Marion Post Wolcott's series of Marylander's enjoying the Hunt Club events in Central Maryland reminds us that not everyone suffered poverty during the Depression. Her almost-cynical photographs of overweight or complacent spectators, similar to those she took in Florida of wealthy racegoers, seem rich with irony when compared to her sensitive portraits of undernourished and impoverished black and white children when on assignment to document FSA clients.

John Vachon. Annapolis,
November 1937. Spectators
at a football game.

USF33 001020-M4

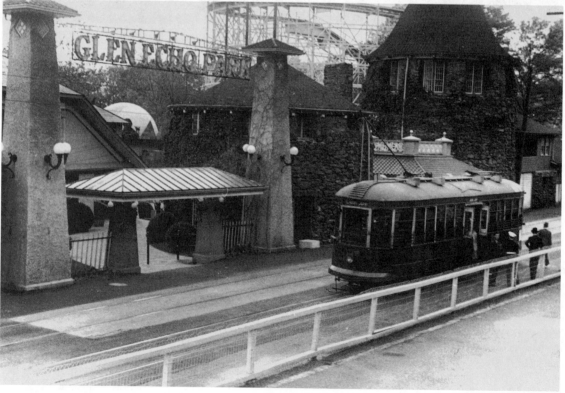

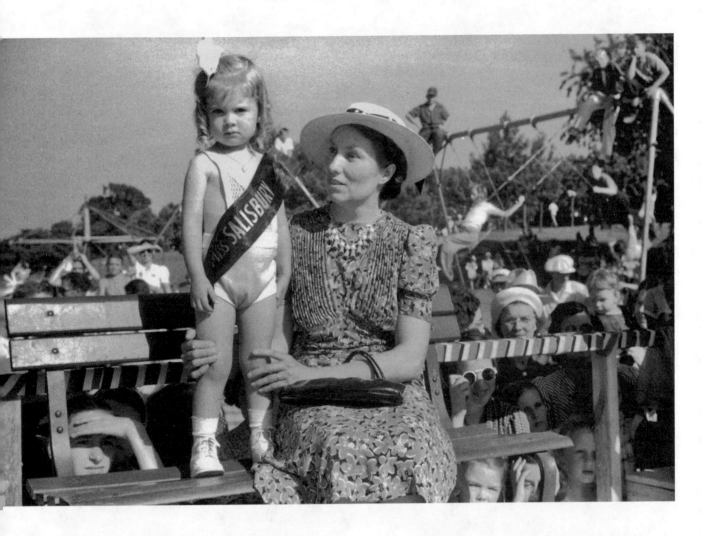

◄ (*top*) Ben Shahn. Accokeek,
Summer 1937. A modern
version of an old medieval
jousting tournament game;
picking off a ring on a lance
while riding by on horseback
at full speed. [*Author's note:
Jousting is the Maryland
state sport.*]

USF33 006500-M4

◄ (*bottom*) David Myers. Glen
Echo, 1939. A view of the
entrance of Glen Echo park,
showing persons alighting
from a Cabin John street car
in front of it.

USF33 015628-M1

Jack Delano. Salisbury,
July 1940. The winner of the
children's division of the
beauty contest held during
the July 4th celebration.

USF33 020634-M2

Marion Post Wolcott. Glyndon
(vicinity), May 1941. Spectators
at the Point to Point cup race
of the Maryland Hunt Club in
the Worthington Valley.

USF34 057377-E

Maryland Goes to War, 1940–1943

Wartime Preparedness | The Military Presence in Maryland

Maryland felt the impact of World War II in many ways, not least of which was the highly visible military presence, particularly in the eastern part of the state. Existing military bases like Fort Meade were expanded, and new ones like Andrews Air Force Base created. The federal government spent $500 million in Maryland; the army alone had sixty-five installations. At Aberdeen Proving Ground, Edgewood Arsenal, Holabird Ordnance Depot, and the Coast Guard depot at Curtis Bay civilian employees worked side by side with military personnel. One scholar has noted that many of the largest of these installations were increasingly located along the coastal plain, further and further from the central cities, requiring construction of peninsular highways and preparing the way for the massive postwar move toward suburbanization.[17]

More than 240,000 Maryland men and women served in the armed forces, and uniforms were everywhere as Maryland participated in training officers and enlisted personnel and Marylanders traveled from segregated units to visit their families back home. (Not until President Harry Truman's Executive Order 9981 in 1948 did American military forces integrate.) Arthur Rothstein's 1942 portrait of Sergeant Franklin Williams and his family is an unusual one, featuring an African-American family. The middle-class comfort of their surroundings is in stark contrast to the many earlier FSA images of impoverished Depression-era rural black families. In Maryland, as in other industrial states such as Michigan and Illinois, the Historical Section's wartime photography of African-Americans often presented them not as victims of economic problems who needed assistance, but as hard-working middle-class citizens contributing to the war effort against a German enemy whose racist treatment of its citizens was abhorrent.

Jack Delano. Baltimore, September 1942 (reenacted). George Camblair waiting his turn for physical examination at the induction station with many other young men. *[Author's note: Jack Delano took a series of 251 photographs of Sergeant George Camblair in September of 1942, primarily of his training at Fort Belvoir, Virginia. As part of the series, Delano had Camblair reenact the enlistment and induction process for the camera.]*

USW3 007955-D

► Arthur Rothstein. Baltimore, May 1942. Sgt. Franklin Williams, home on leave from army duty, posing for a family portrait with his mother and father beside him and his nephew on his lap.

USW3 001036-D

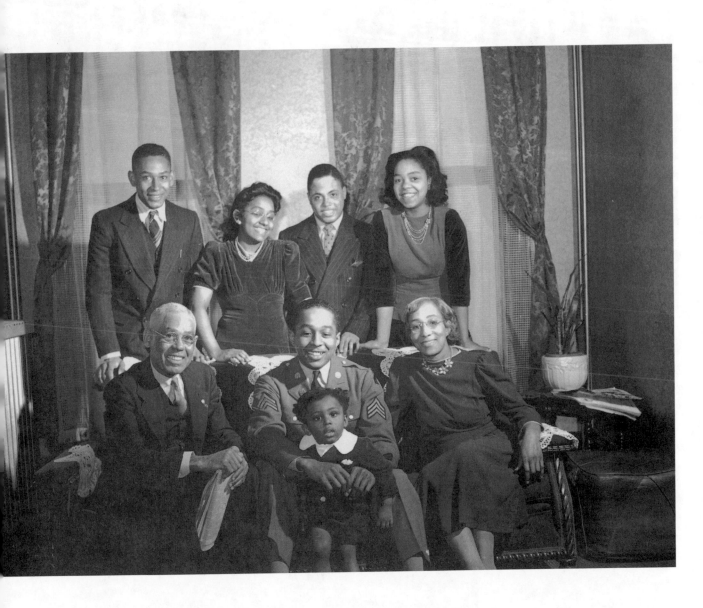

Lieutenant Whitman. U.S.
Naval Academy, Annapolis,
July 1942. Midshipmen
in formation.

USW3 004944-E

───────

► Jack Delano. Edgewood
arsenal, June 1942. Gas
demonstration. Recon-
ditioning of gas masks at
the gas mask factory.

USW3 004783-D

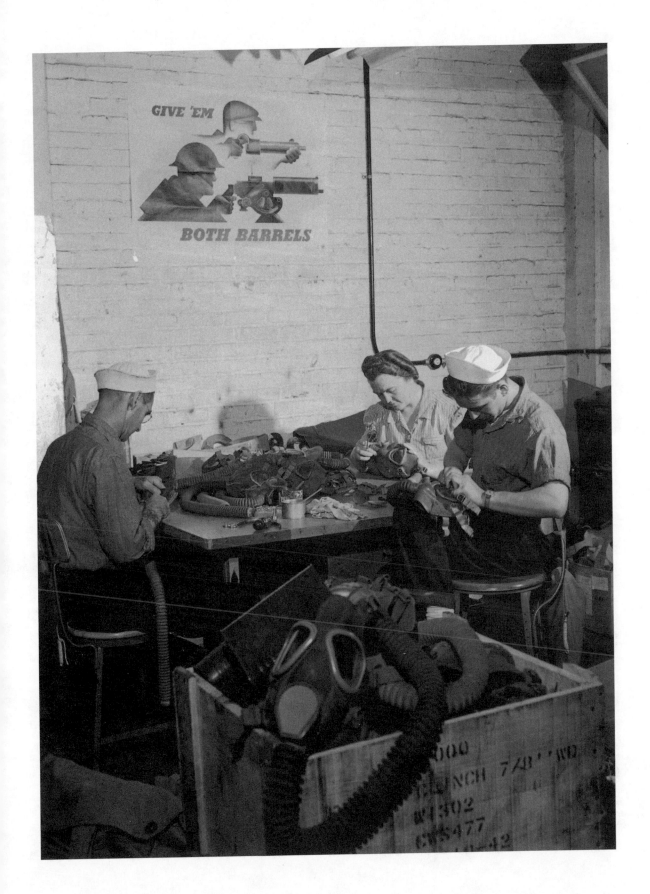

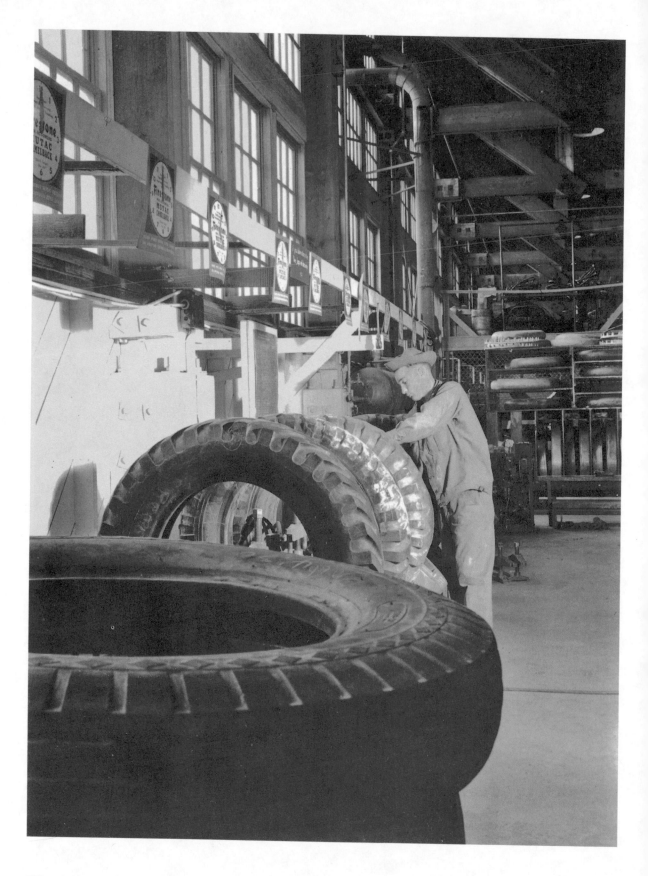

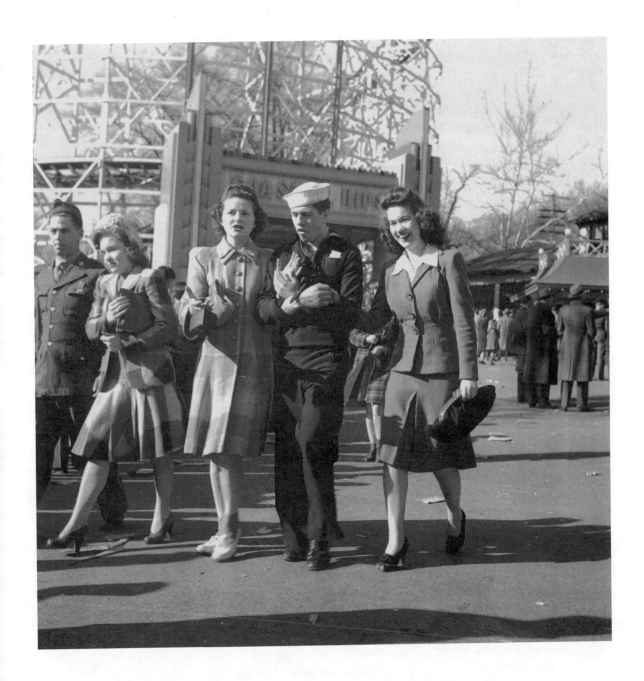

◄ Ann Rosener. Holabird ordnance depot, Baltimore, May 1943. After having been repaired, tires which need only spot recapping are curing in these section molds. They remain in these molds under pressure for about 1 hour and 45 minutes.

USW3 025360-D

Esther Bubley. Glen Echo, April 1943. Servicemen and girls at the amusement park.

USW3 022799-E

The Sinews of War—Industry in Maryland

Federal financing guaranteed that Maryland would be a major player as part of the "Arsenal of Democracy" in the industrial race to win the war—a race begun long before the attack on Pearl Harbor on December 7, 1941, brought American troops into the conflict. From 1940 onward the Reconstruction Finance Corporation, created in 1932 to lend money to states for emergency relief and industrial recovery, invested $70 million in defense plants in Maryland. Although its wartime industries were many and varied, the state specialized in two essential areas of wartime production: aircraft and shipping. Beginning in 1940, investment and employment in those and other industries expanded rapidly. The Glenn L. Martin Company, which in 1929 built a new plant of its Cleveland-based aircraft company on a 1,200-acre site on the Middle River in Baltimore County near the Chesapeake Bay, expanded to create the largest aircraft assembly floor in the world, with a work force of 37,000. At its height in World War II, the Fairchild Aircraft plant in Hagerstown, which had moved to the city in 1931, employed nearly 10,000 people. Overall employment in the Maryland aircraft industry grew from 11,000 in 1940 to more than 50,000 in 1943.[18]

Closer to Baltimore, Bethlehem Steel, originally constructed at Sparrows Point near shipping facilities in the 1890s, expanded substantially during World War II, its work force rising to 37,000. At the Bethlehem-Fairfield Shipyards, Maryland workers built more than 500 Liberty Ships and Victory Ships, cutting the production time for a vessel from 110 days to 52 days by August of 1942.

Creating the work force for this massive industrial effort brought about major changes in the Maryland labor market, and the industrial photography of the FSA/OWI assignments documented the effects of those changes. Women were heavily recruited by the U.S. Employment Service for war work, and many of the new employees at defense plants were female. While often their jobs were traditional twentieth-century women's work, such as telephone operator, secretary, or bookkeeper, at the Bethlehem-Fairfield Shipyards they did jobs previously reserved for men, operating massive cranes or working as riveters and welders. African-Americans as a group also benefited from the growing need for skilled labor. Before the war, fewer than 8 percent of Baltimore's black population worked in industry; spurred by the Federal Fair Employment Practices Commission and finally by an executive order from President Roosevelt, Maryland industry grudgingly opened its doors to black workers, and at the war's end African-Americans comprised 17.6 percent of the Baltimore industrial work force. Despite the amity suggested by photographs Arthur Siegel took of black and white workers, tensions on the shop floor over

such issues as separate versus integrated lockers and water fountains erupted into a strike by white workers at the Bethlehem-Fairfield Shipyards in the summer of 1943, and another strike followed that fall over integrating 1,700 black employees into the Point Breeze plant of Western Electric.[19]

Arthur Siegel, a gifted industrial photographer from Detroit, took more than 700 photographs of the Bethlehem-Fairfield Shipyard assembly-line production system in May of 1943, of which a handful are reproduced here. The photographs document the enormous size of the shipyard and the massive investment in infrastructure and human labor that helped to tip the balance in the European and Pacific theaters of war toward Allied victories in 1945.

Edwin Rosskam. Frederick
(vicinity), June 1941.
Compressor truck and quarry
worker at a limestone quarry.
USF34 012813-D

▶ John Vachon. Sparrows
Point, September 1940.
The Bethlehem Steel mill.
USF34 061321-D

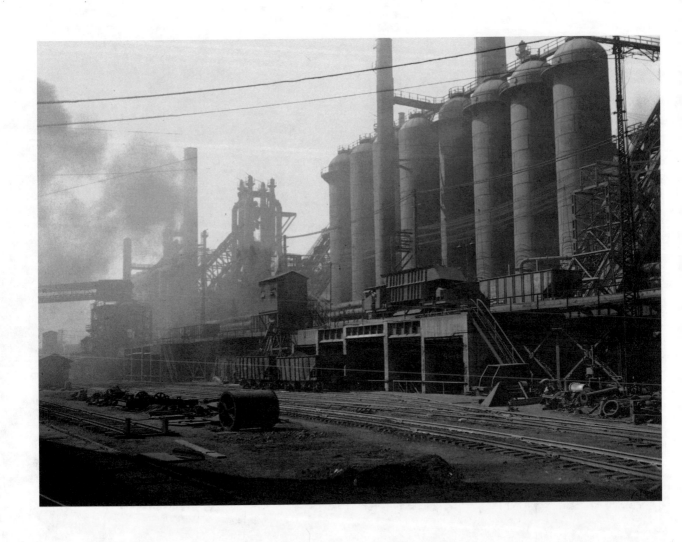

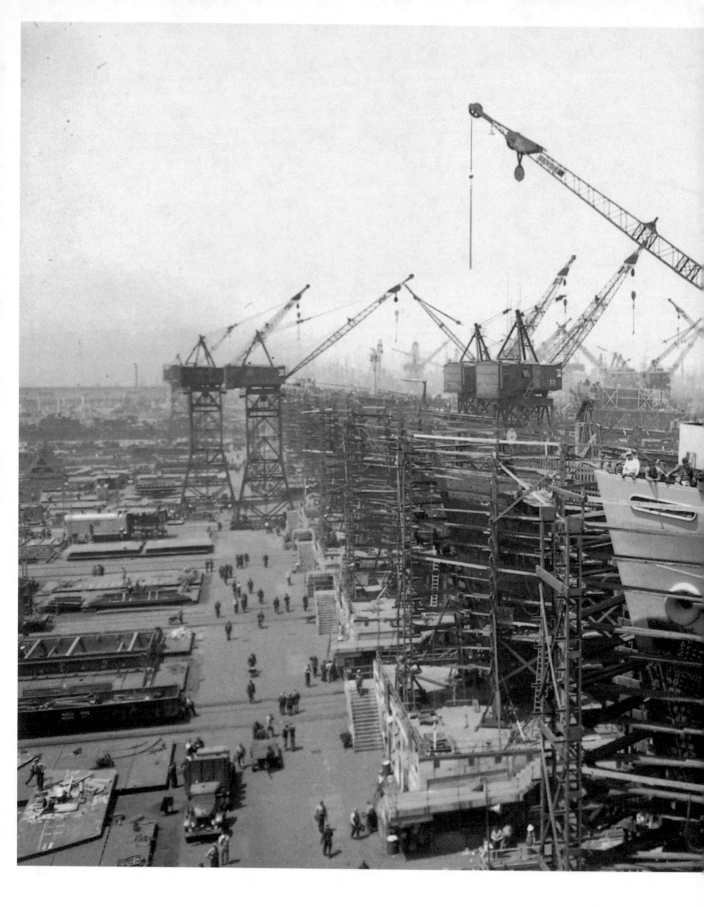

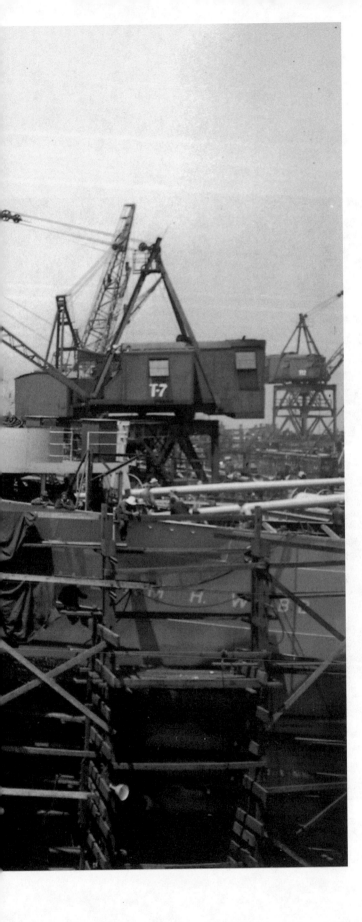

Arthur Siegel. Bethlehem-
Fairfield Shipyards,
Baltimore, May 1943. General
view of the shipyards.

USW3 026370-D

Arthur Siegel. Bethlehem-
Fairfield Shipyards,
Baltimore, May 1943. Master
cards of all employees.

USW3 024479-D

◄ Arthur Siegel. Bethlehem-
Fairfield Shipyards,
Baltimore, May 1943. A view
of a drafting room.

USW3 024502-D

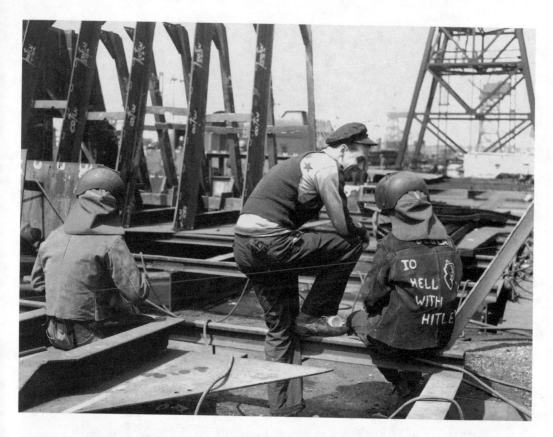

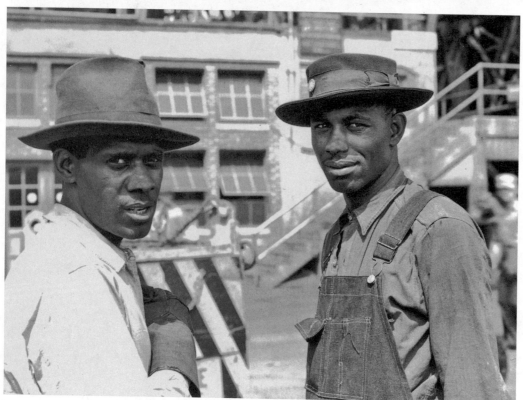

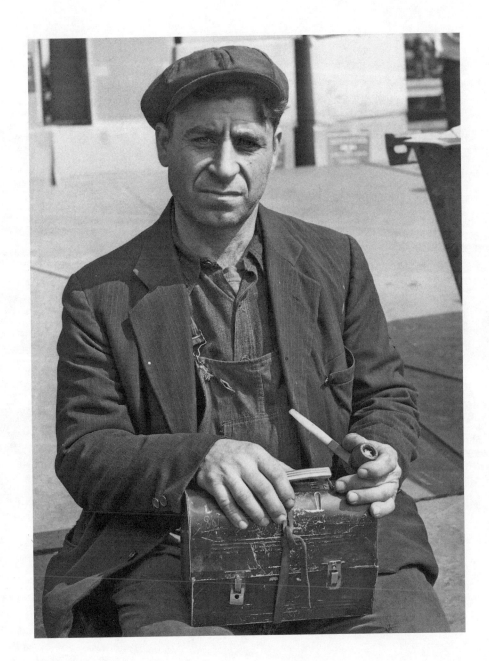

Arthur Siegel.
Bethlehem-Fairfield
Shipyards, Baltimore,
May 1943. An Italian
shipyard worker.
USW3 026317-D

◄ (*top*) Arthur Siegel.
Bethlehem-Fairfield
Shipyards, Baltimore,
May 1943. Lunch-
time discussion.
USW3 023630-D

◄ (*bottom*) Arthur Siegel.
Bethlehem-Fairfield
Shipyards, Baltimore,
May 1943. Negro workers.
USW3 026323-D

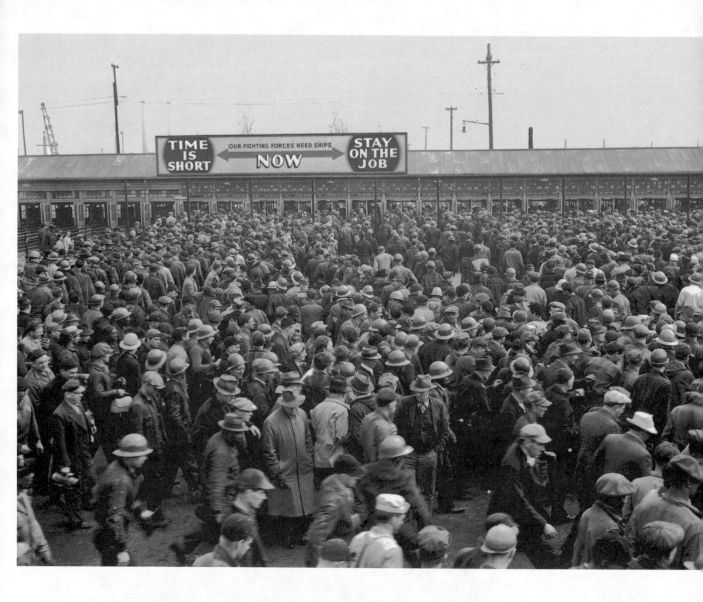

Arthur Siegel. Bethlehem-
Fairfield Shipyards, Baltimore,
May 1943. Day shift lining
up in front of the time clocks.
USW3 023543-D

► Arthur Siegel. Bethlehem-
Fairfield Shipyards,
Baltimore, May 1943. The
shipyards at night with
a welder in the foreground.
USW3 025870-D

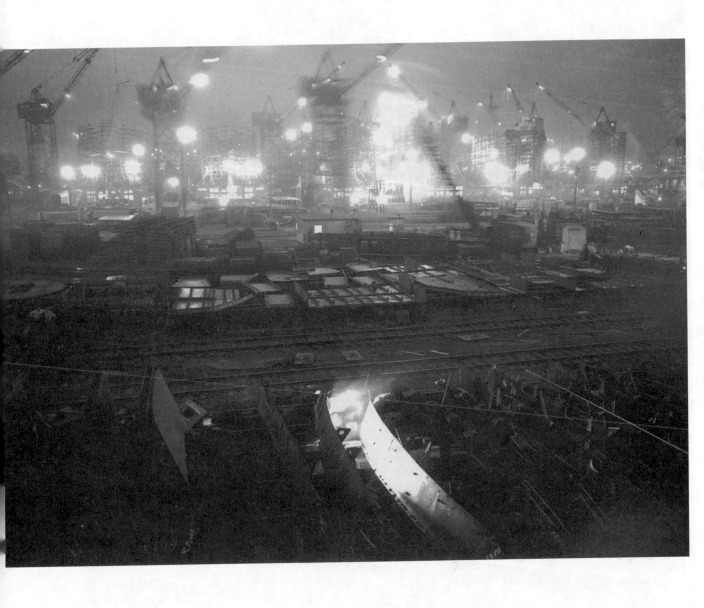

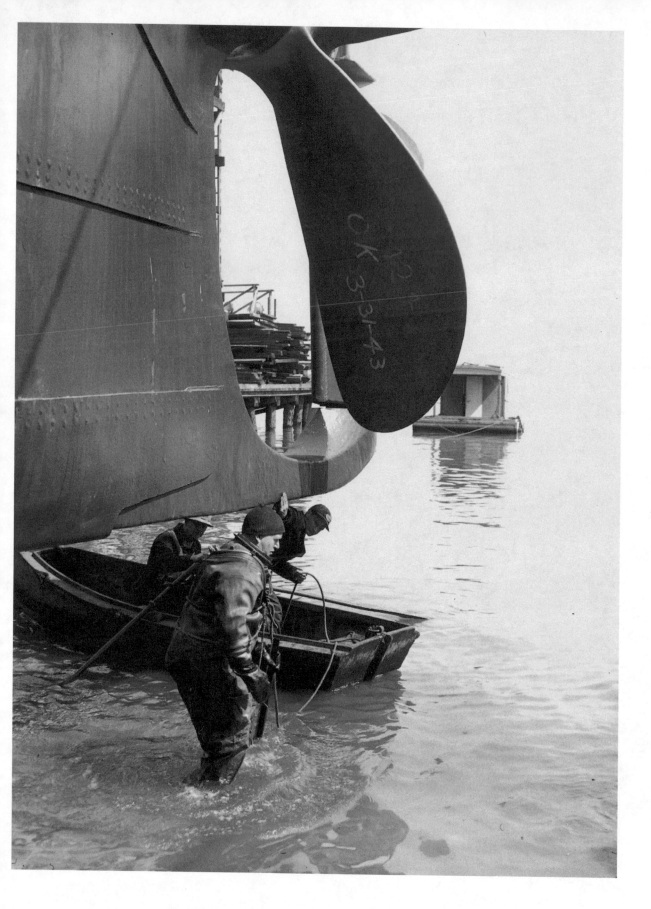

Life on the Home Front | Wartime Baltimore, 1942–1943

The civilian population of Baltimore increased by 134,000 between 1940 and 1943. For the average Baltimorean, the most immediate impact of this population growth was the pressure on transportation networks and housing that these new neighbors from other parts of Maryland and out of state created. By the end of the war, nearly 30,000 new housing units had been built on the outskirts of the city or the suburbs, most of them near the expanded or newly developed plants at Sparrows Point and at Middle River. Those who still lived within the city turned to public transit to get to their jobs. Marjory Collins went to Baltimore on assignment in April of 1943 to record the multiple ways in which war workers were coping with the transportation crisis.

Not all work during these years was directly in wartime production, although it was connected to the war effort. Truckers continued to carry freight on the highways; trolley repairmen kept their vehicles ready for the road; student nurses at Johns Hopkins University Hospital in central Baltimore provided care for the health of young civilians. Signs posted in their workplaces reminded them constantly that even these tasks were an important part of the war effort.

Arthur Siegel. Bethlehem-
Fairfield Shipyards,
Baltimore, May 1943. Diver
preparing to inspect the
outboard launching ways.
USW3 023655-D

Marjory Collins. Baltimore,
April 1943. Workers arriving
in shared cars at the Glenn L.
Martin camouflaged parking
space at 7 AM.

USW3 022155-D

► Marjory Collins. Baltimore,
April 1943. Bethlehem-
Fairfield shipyard workers
boarding a former Wilson
line pleasure boat, now used
for workers' transportation,
to get back to Baltimore
from the second shift.
*[Author's note: An adjoining
image in the series has this
additional caption infor-
mation: "Eighteen hundred
workers are carried from the
Bethlehem-Fairfield Shipyard
to Baltimore on a former
Wilson line pleasure boat. The
trip takes twenty minutes."]*

USW3 022568-E

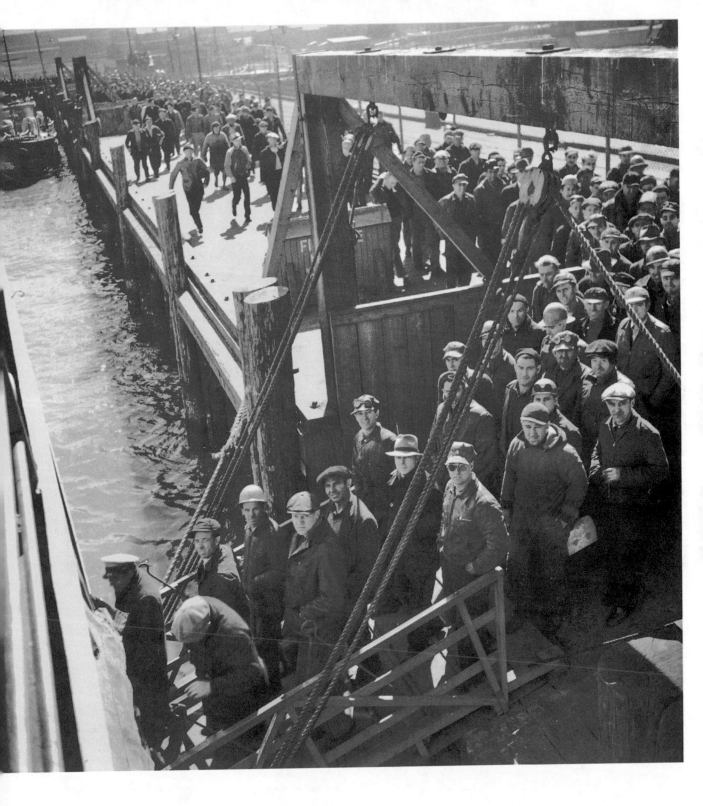

John Vachon. Baltimore, March 1943. Truck drivers getting their orders to go out at the dispatchers office, Davidson truck terminal.

USW3 020296-D

► Marjory Collins. Baltimore, April 1943. Repairing the motor of a PCC trolley, most recent trolley model designed in 1936 by a group of manufacturers and Transit companies in an effort to standardize, simplify, and bring down the price, at the damage repair shop, maintenance terminal of the Baltimore Transit company.

USW3 022144-D

► (*next page*) Ann Rosener. Johns Hopkins Hospital, Baltimore, May 1943. Student nurse at work in the pediatric ward.

USW3 035262-D

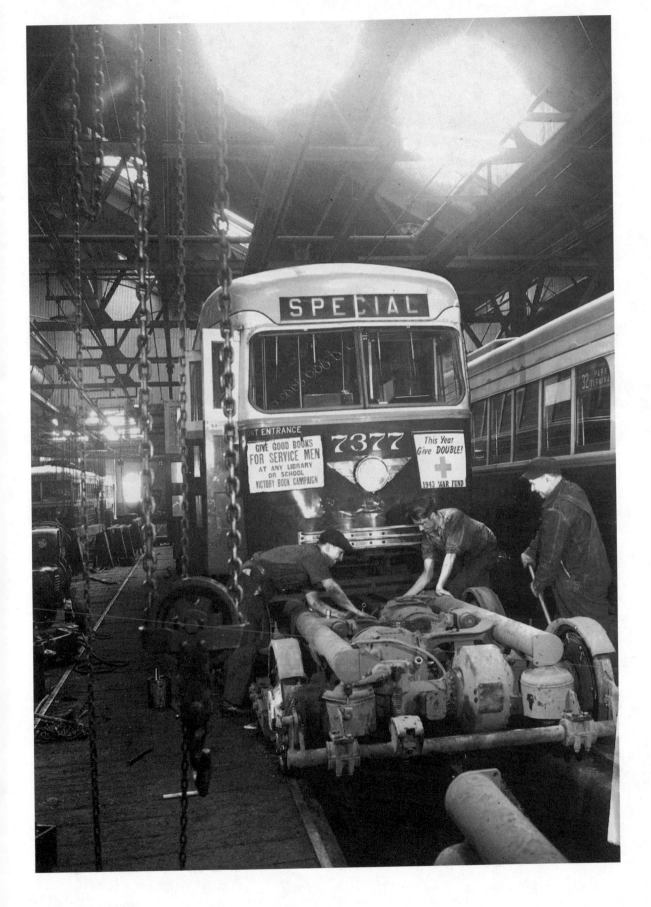

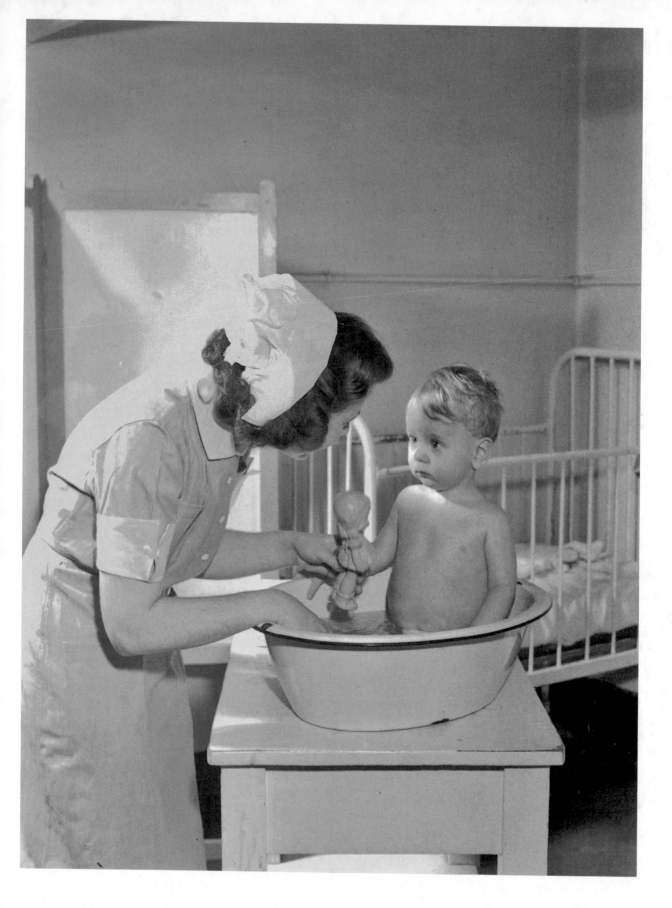

Civilian Life in Wartime

Every aspect of life in Maryland was affected by the war effort. New workers and their families flooded into the areas around Baltimore as Bethlehem-Fairfield Shipyard, Glenn L. Martin Company aircraft plants, Bethlehem Steel, and others expanded their work force. Young professionals and an army of secretaries joined the growing bureaucracy of the national government in Washington. All of these newcomers needed housing, schools, day care centers for families where women were employed in defense work, laundries, new bus and trolley routes, and a host of other services. Existing Maryland suburban communities around Washington, D.C., like Bethesda, Silver Spring, and Chevy Chase, grew rapidly. Around Baltimore, some industries like the Glenn L. Martin Company provided temporary housing for their workers, and whole cities of trailer homes sprang up in what had shortly before been corn or hay fields. In some communities, schools went on double shifts to accommodate all the children. The still new Greenbelt, carefully designed as a cooperative community, doubled in size almost overnight, and many of the new defense worker residents had little understanding or appreciation for the established cooperative networks of the existing neighborhoods.[20]

Civilians faced shortages of everything from sugar to tires, as clothing, food, gasoline—anything that was needed for the military, for feeding and clothing America's European allies, or for use in industry—was rationed. Families cultivated "victory gardens," and urban and suburban women learned to can and preserve foods. People took public trains and buses rather than driving their cars, waiting patiently in long lines. Home repair of clothing, shoes, automobiles, and appliances became the mark of a good citizen as people applied themselves to the slogan "Use it Over, Wear it Out, Make it Do." Even children and teenagers were drafted into the war effort, learning essential skills for industrial employment in special classes in high school, working after school to alleviate wartime labor shortages, or participating in scrap metal drives.[21]

Not all of civilian life was devoted to work, of course. Couples dancing the jitterbug at the senior prom in Greenbelt, or an OWI photographer taking a day off from documenting the heavy industry in the Bethlehem-Fairfield Shipyard to watch Count Fleet win the Preakness Stakes, represented civilians everywhere who tried to maintain a "normal" life on the home front, even as they read the newspapers avidly and listened apprehensively to the radio for news from the faraway European, African, and Pacific fronts. Communities throughout the state, much like Emmitsburg, showed their support for their men and women, displaying flags and photographs of those in service in the public square. Photographer Marjory Collins went out on a special

assignment on election day in 1942 to provide the Office of War Information with propaganda photographs of democracy in action during wartime. It was not accidental that she chose an election scene in which an African-American man is voting. Ironically, the caption scarcely hints at the strongly entrenched racism, segregation, and paternalism that blacks in Maryland continued to face; a successful civil rights movement in the state was still more than a decade in the future. Nevertheless, her photos capture the serious, purposeful essence of small-town polling events. And for some, the war came home with finality in the death of a loved one, a friend, or a neighbor.

John Collier, Jr. Middle River,
a small crossroads in the
vicinity of Baltimore, August
1943. Farm Security Admin-
istration housing project (later
administered by the National
Housing Agency) for Glenn L.
Martin aircraft workers. Trailer
home of Mr. and Mrs. George
Davis, an airplane worker
at the Glenn L. Martin plant.

USW3 036016-C

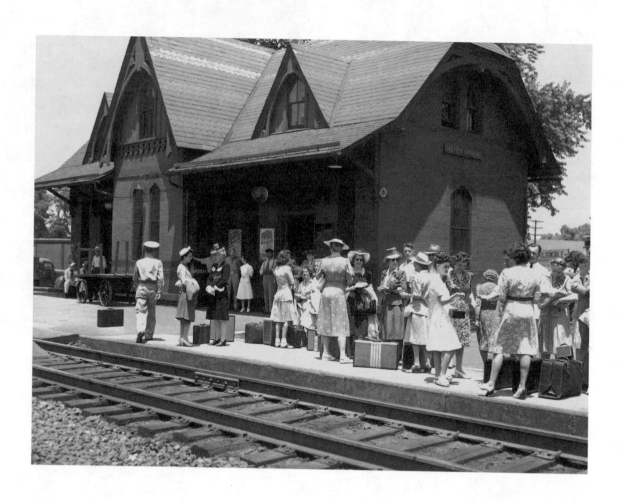

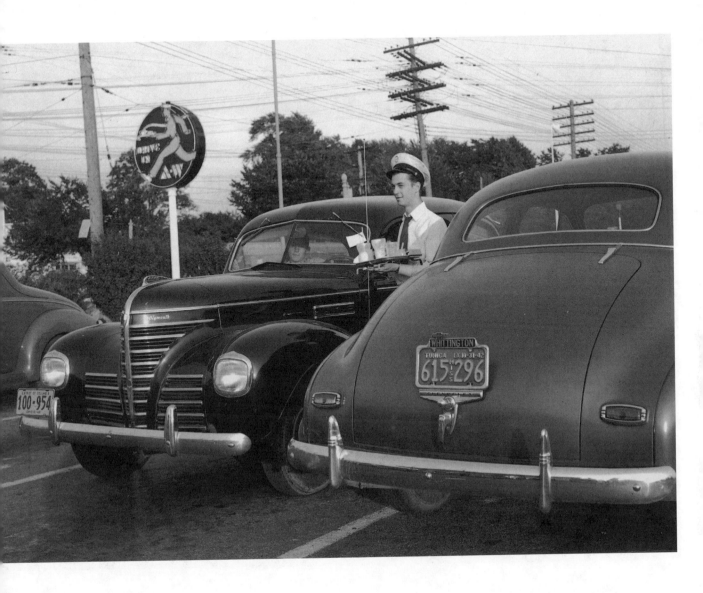

Marjory Collins. Chevy Chase,
June–July 1942. Serving supper
to motorists at a Hot Shoppe
on Wisconsin Avenue, just over
the District line in Maryland.

USF34 100250-D

◄ Ann Rosener. Silver Spring,
June 1943. People waiting for a
train at the railroad station.

USW3 033279-D

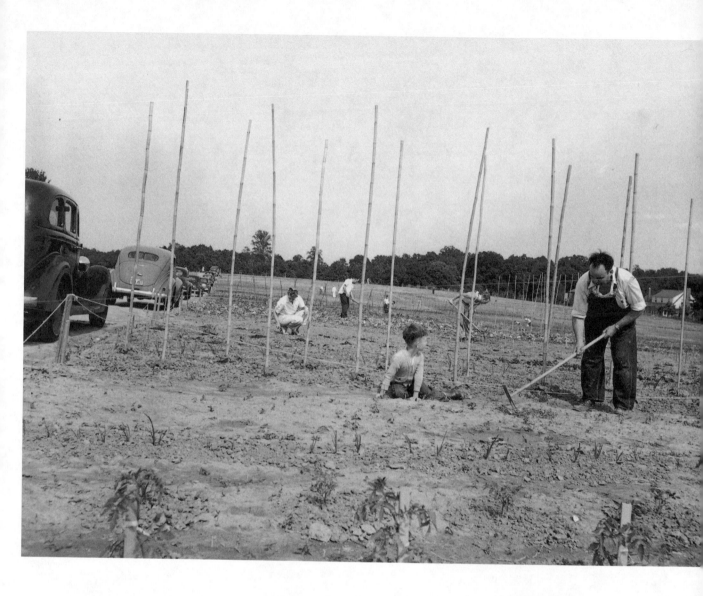

Ann Rosener. Silver Spring, June 1943. Sunday morning in many United States communities finds all the neighbors getting together at their victory gardens. Through cooperation of the local organizations thousands of vacant lots in thousands of cities are being transformed into gardens.

USW3 029032-D

► Ann Rosener. Silver Spring, June 1943. A man repairing his automobile.

USW3 029020-D

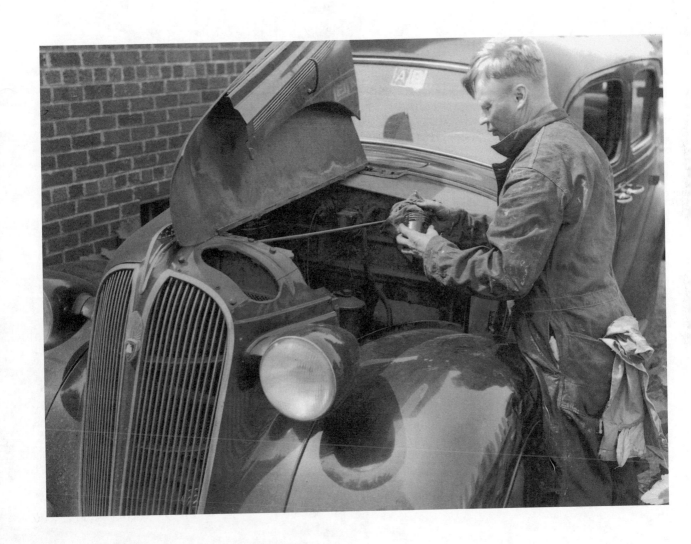

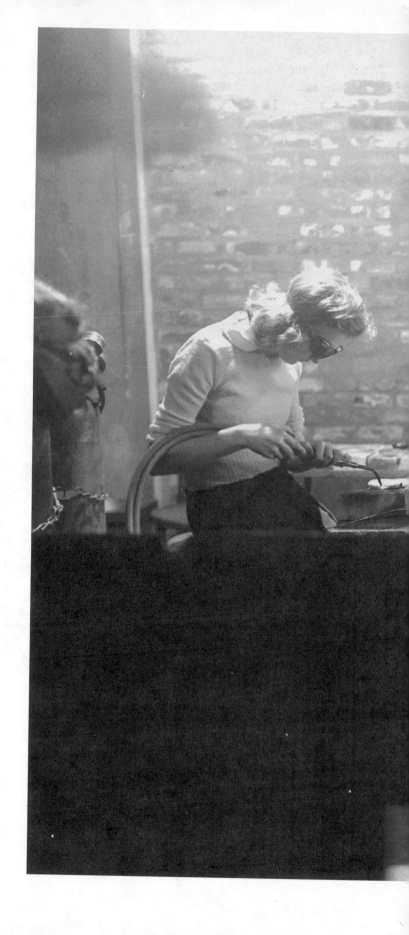

William Perlitch.
Montgomery Blair High
School, Silver Spring,
October 194[2].
Learning to weld.
USW3 024627-C

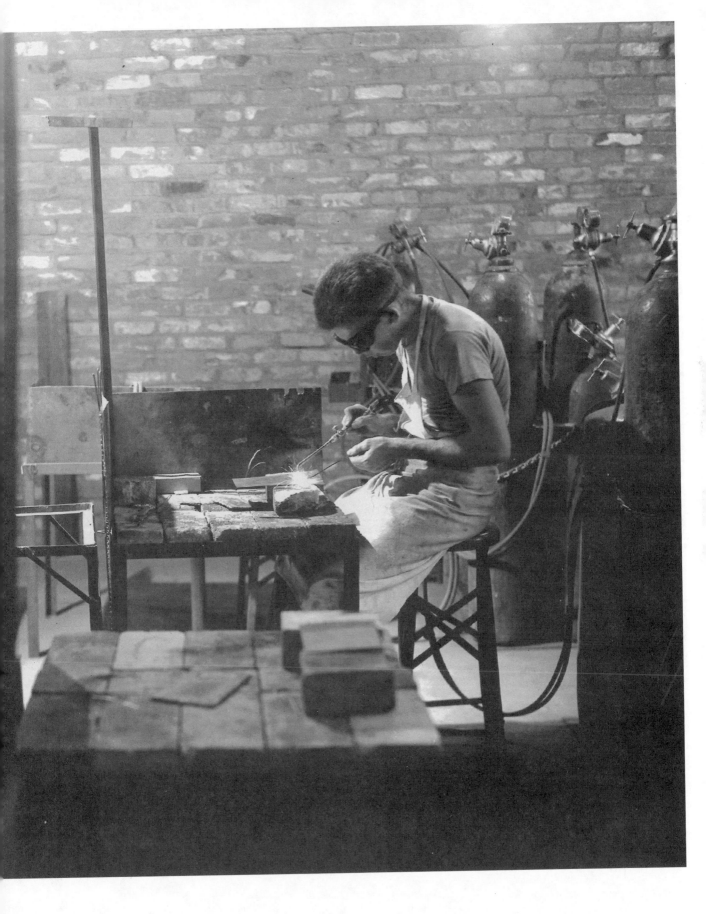

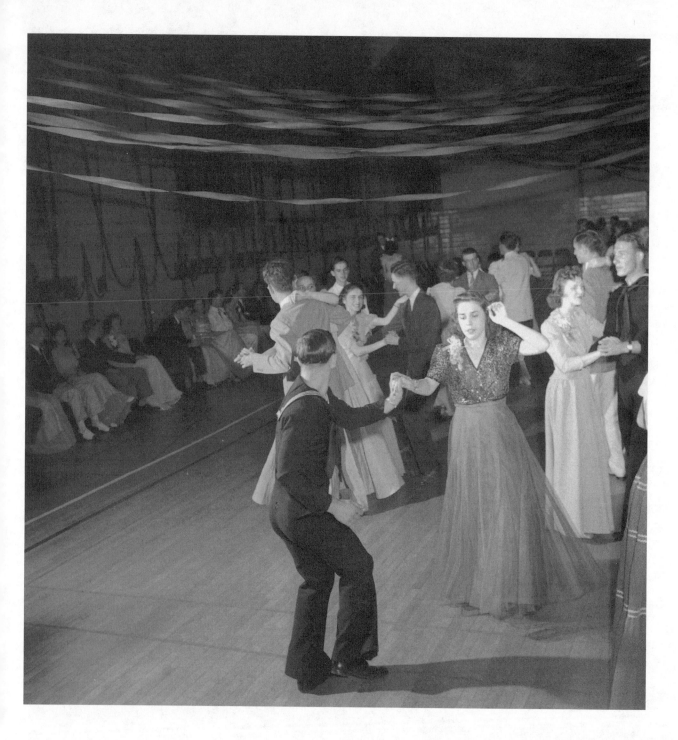

Marjory Collins. Greenbelt,
May–June 1942. Sailor jitter-
bugging at the senior prom.
USW3 003702-E

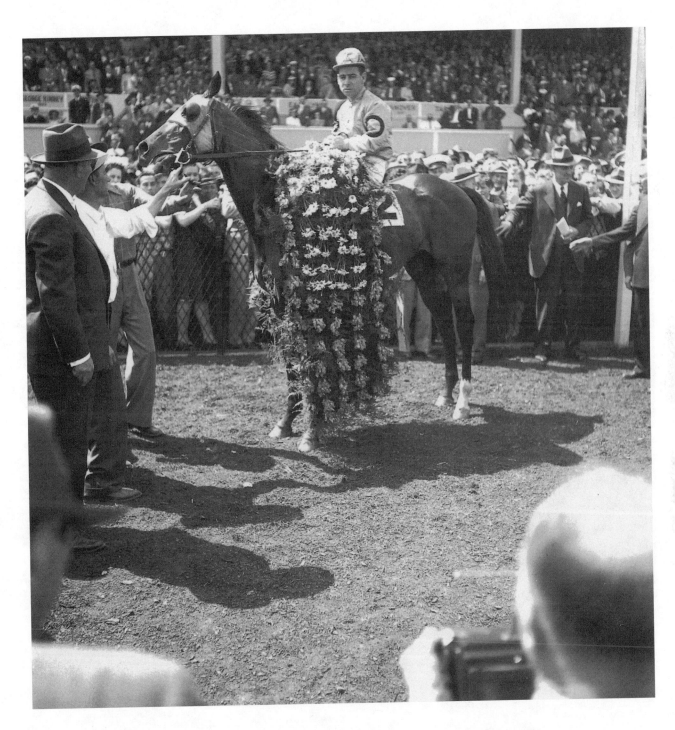

Arthur Siegel. Pimlico
Race Track, near Baltimore,
May 1943. Count Fleet,
famous race horse, covered
with the floral wreath, after
winning the Preakness Cup.

USW3 026516-E

Marjory Collins. Emmitsburg,
February 1943. Square.

USW3 017682-D

► (*top*) Marjory Collins.
Emmitsburg, February 1943.
Window display
in the general store.
USW3 017681-D

► (*bottom*) Marjory Collins.
Olney, November 1942.
Showing a Negro how to vote
at the polls on election day.
USW3 010308-D

152

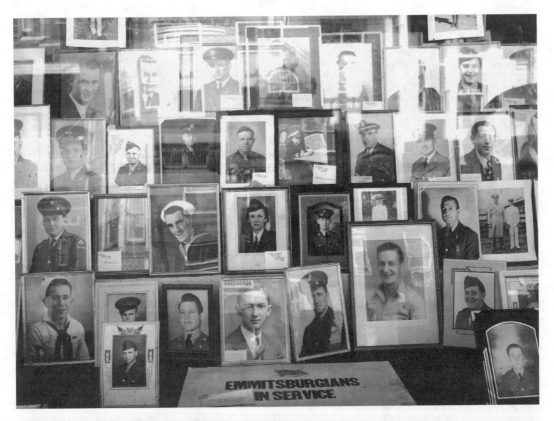

Jack Delano. Baltimore, June 1943. Funeral of a merchant seaman. Mourning neighbors and friends.

USW3 031163-E

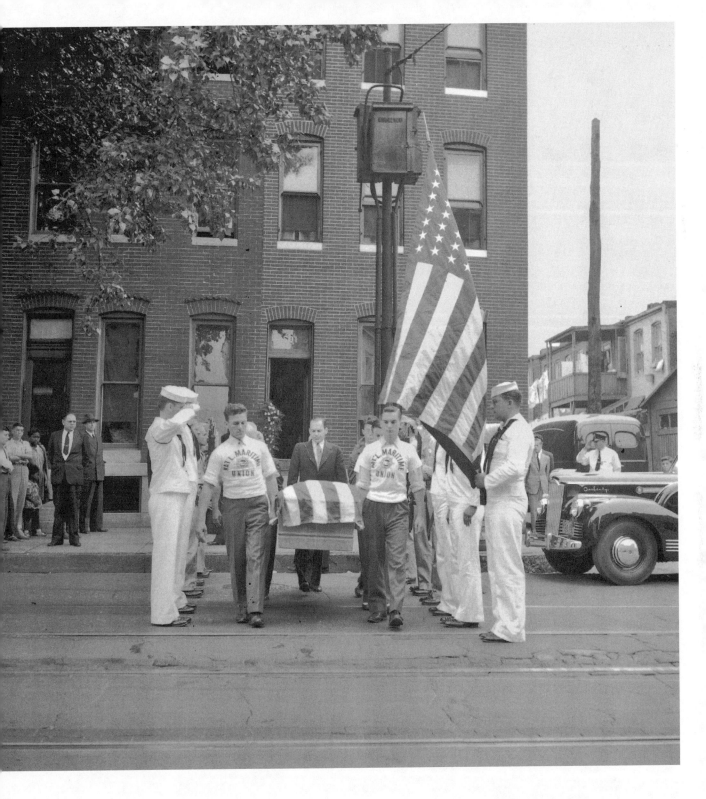

Jack Delano. Baltimore,
June 1943. Funeral of a
merchant seaman. Pallbearers
with flag-covered casket.

USW3 031169-E

Notes

The Context

1 Although written almost half a century ago, the most complete discussion of the history and purpose of the FSA is still Baldwin, *Poverty and Politics*. The photographs of the Historical Section are probably its best-known legacy. An extensive bibliography of the many books written about the FSA/OWI photographs is in Mora and Brannan, *FSA*, 354–57. Mora and Brannan also provide important essays that discuss the record of the Historical Section and the work of its photographers and evaluate its impact on the origins and development of documentary photography.

2 The images can be seen at the Prints and Photographs Division website, at www.loc.gov/rr/prints/. Fleischhauer and Brannan, eds., *Documenting America, 1935–1943*, 338, estimated that the collection contains over 180,000 non-duplicated negatives.

3 Unless noted otherwise, the discussion that follows is based on Brugger, *Maryland*, Chapter 10; Argersinger, *Toward a New Deal in Baltimore*; Dorothy M. Brown, "Maryland Between the Wars," Chapter 9 in Walsh and Fox, eds., *Maryland*; Schulz, "Prosperity, Depression, and War, 1917–1945," Chapter 6 in Chapelle et al., *Maryland*; and Olson, *Baltimore*, 332–46.

4 Argersinger, *Toward a New Deal in Baltimore*, 5–7; the Baltimore Association of Commerce quote is on p. 7; Brugger, *Maryland*, 495.

5 Brown, "Maryland Between the Wars," in Walsh and Fox, eds., *Maryland*, 731–37.

6 Argersinger, *Toward a New Deal in Baltimore*, 3, 8, 19; Brown, "Maryland Between the Wars," in Walsh and Fox, eds., *Maryland*, 744–45.

7 Schulz, "Prosperity, Depression, and War," in Chapelle et al., *Maryland*, 236.

8 Olson, *Baltimore*, 340; Argersinger, *Toward a New Deal in Baltimore*, 62–63.

9 Olson, *Baltimore*, 341.

10 Schulz, "Prosperity, Depression, and War," in Chapelle et al., *Maryland*, 241–42.

11 Brown, "Maryland between the Wars," in Walsh and Fox, eds., *Maryland*, 756–59.

12 Brugger, *Maryland*, 518–20; Sherrilyn A. Ifill, *On the Courthouse Lawn: Confronting the Legacy of Lynching in the Twenty-first Century* (Boston: Beacon Press, 2007).

13 Brugger, *Maryland*, 521–23; Brown, "Maryland Between the Wars," in Walsh and Fox, eds., *Maryland*, 721–22.

14 Brugger, *Maryland*, 528–29.

15 Hurley, *Portrait of a Decade*, provides a useful biographical overview of Roy Stryker's early training and career and the beginnings of the Historical Section.

16 Knepper, *Greenbelt, Maryland*, 14.

17 Mora and Brannan, *FSA*, 257.

18 Baldwin, *Poverty and Politics*.

19 See Knepper, *Greenbelt, Maryland*, especially 13–39.

20 Carson, "Interpreting National Identity in Time of War"; see also Schulz, *A South Carolina Album*, 11–12, and Schulz, *Bust to Boom*, 36–37.

21 Fleischhauer and Brannan, eds., *Documenting America*, Introduction.

22 On Stryker's career at Standard Oil of New Jersey and the Pittsburgh Photographic Library, after he left the federal government, see Plattner, *Roy Stryker*; Keller, *The Highway as Habitat*; Schulz and Plattner, *Witness to the Fifties*.

23 See, for instance, Curtis, *Mind's Eye, Mind's Truth*; Guimond, *American Photography and the American Dream*; Stange, *Symbols of Ideal Life*; Stott, *Documentary Expression and Thirties America*; or the more balanced and thoughtful discussion in Trachtenberg, *Reading American Photographs*.

24 Stryker and Wood, *In This Proud Land*, 7.

25 The "shooting scripts" have played a significant part in the scholarly controversy over the reliability of the FSA/OWI images. The Library of Congress collection of the administrative records of Stryker's Historical Section contains much of his correspondence with photographers, and current staff have digitized all examples they have found of specific instructions given for any assignment. These can be found under the title "Farm Security Administration / Office of War Information Written Records: Selected Documents" on the Prints and Photographs Division website at http://www.loc.gov/rr/print/coll/fsawr/fsawr.html .

26 Like the shooting scripts, the "killed" images have been a subject for scholarly evaluation and criticism of the FSA. Fleischhauer and Brannon, eds., discuss in detail the process of selection in *Documenting America*, 338–40, and the Library of Congress Prints and Photographs Division staff have written a more recent description of the practice in the "Background and Scope" discussion accompanying the online publication of FSA/OWI negatives; see www.loc.gov/pictures/collection/fsa/background.html. See also Jones, *Killed*.

27 Alan Trachtenberg, "From Image to Story: Reading the File," in Fleischhauer and Brannan, eds., *Documenting America*, 66.

28 Hurley, *Portrait of a Decade*; Schulz, *Bust to Boom*, 35–36.

29 Archives of American Art, Smithsonian Institution, Richard Doud interview with Arthur Rothstein, May 25, 1964, 30.

30 Fleischhauer and Brannan, eds., *Documenting America*, 338–40; Hurley, *Marion Post Wolcott*.

31 FSA Textual Records, Library of Congress, Box 1, "Clearances."

32 Quoted in Keller, *The Highway as Habitat*, 201.

33 For instance, only five FSA photographers visited South Carolina and Kansas, and six traveled to Michigan. See Schulz, *A South Carolina Album*; Schulz, *Bust to Boom*; Schulz, *Michigan Remembered*.

34 The Prints and Photographs Division of the Library of Congress maintains an extensive bibliography related to its FSA/OWI collection on its website, including a list of known biographies of FSA/OWI photographers. See www.loc.gov/pictures/collection/fsa/bibliography. For oral interviews by Doud on deposit in the Archives of American art, go to www.aaa.si.edu/collections/interviews and search under each photographer's name.

35 Bubley, *The Photographs of Esther Bubley*; Fleischhauer and Brannan, eds., *Documenting America*; Plattner, Roy Stryker; Fisher, *Let Us Now Praise Famous Women*.

36 Weiglie, *Women of New Mexico*; Gidley, "John Collier, Jr."; Fleischhauer and Brannan, eds., *Documenting America*; Doty et al., *Photographing Navajos*.

37 Carson, "Interpreting National Identity in Time of War," 128–29, citing Marjory Collins Papers deposited in the Schlesinger Library.

38 Mora and Brannan, *FSA*, 270–89; Fleischhauer and Brannan, eds., *Documenting America*; Fisher, *Let Us Now Praise Famous Women*.

39 Fleischhauer and Brannan, eds., *Documenting America*, 337.

40 Delano, *Puerto Rico Mio*; O'Neal, *A Vision Shared*; Delano, *The Photographs of Jack Delano*.

41 Archives of American Art, Smithsonian Institution, oral history interview with Roy Stryker by Richard Doud, January 23, 1965, 2.

42 Schulz, *Michigan Remembered*.

43 Mora and Brannan, *FSA*, 110–23; O'Neal, *A Vision Shared*.

44 O'Neal, *A Vision Shared*; Hurley, *Russell Lee*; Lee, *The Photographs of Russell Lee*; Mora and Brannan, *FSA*, 234–53.

45 Archives of American Art, Smithsonian Institution, oral history interviews with Roy Stryker by Richard Doud, October 17, 1963, June 13 1964, and January 23, 1965. http://www.aaa .si.edu/collections/interviews/oral-history-interview-roy-emerson-stryker-12480.

46 Mydans, *Carl Mydans*; O'Neal, *A Vision Shared*; Mora and Brannan, *FSA*, 90–109; Mydans, *The Photographs of Carl Mydans*.

47 Fisher, *Let Us Now Praise Famous Women*; Brannan, "Women Photojournalists."

48 Schulz, *Bust to Boom*; Doud, Interview with Edwin and Louise Rosskam; Mora and Brannan, *FSA*, 148–67.

49 O'Neal, *A Vision Shared*; Fleischhauer and Brannan, eds., *Documenting America*; Mora and Brannan, *FSA*, 124–45; Rothstein, *The Photographs of Arthur Rothstein*.

50 O'Neal, *A Vision Shared*, 46.

51 Pratt, *The Photographic Eye of Ben Shahn*; O'Neal, *A Vision Shared*; Mora and Brannan, *FSA*, 44–67; Raeburn, *Ben Shahn's American Scene*.

52 Doty, ed., *Photography in America*; Viskochil, "Arthur Siegel," in Evans, ed., *Contemporary Photographers*, 1025–26; Schulz, *Michigan Remembered*.

53 Brian Vachon, "John Vachon: A Remembrance," *American Photographer* 3 (October 1979), 36, quoted in Fleischhauer and Brannan, eds., *Documenting America*, 90.

54 O'Neal, *A Vision Shared*; Fleischhauer and Brannan, eds., *Documenting America*; Vachon, *John Vachon's America*; Mora and Brannan, *FSA*, 212–33.

55 O'Neal, *A Vision Shared*; Hurley, *Marion Post Wolcott*; Mora and Brannan, *FSA*, 168–87; Wolcott, *The Photographs of Marion Post Wolcott*.

The Photographs

1 Maryland Geological Survey, Maryland Department of Natural Resources, *A Brief Description of the Geology of Maryland*. www.mgs.md.gov/esic/brochures/mdgeology.html.

2 Dorothy M. Brown, "Maryland Between the Wars," Chapter 9 in Walsh and Fox, eds., *Maryland*, 736.

3 Ibid., 708, 756. On nineteenth-century coal strikes, see Brugger, *Maryland*, 338–40.

4 Brugger, *Maryland*, 796.

5 Writers' Program of the Work Projects Administration in the State of Maryland, *Maryland, A Guide to the Old Line State* (New York: Oxford University Press, 1940), 73.

6 *Book of the Royal Blue*, 1907, reprinted in Warren and Warren, *Maryland Time Exposures*, 55.

7 *Maryland, A Guide to the Old Line State*, 65; Wennerstein, *Maryland's Eastern Shore*, 235–36; Brown, "Maryland Between the Wars" in Walsh and Fox, eds., Maryland, 758–59.

8 McDaniel, *Hearth and Home*, describes both the activities and furnishing inside Southern Maryland freedmen's homes and their gradual abandonment after 1945.

9 The source for this discussion is Knepper, *Greenbelt, Maryland*, 13–39. Greenhills, Ohio, near Cincinnati, and Greendale, Wisconsin, outside of Milwaukee, are the other two completed suburban communities created by the RA.

10 Ibid., 32–34. African-Americans were not eligible for selection. The original plan for Greenbelt had envisioned a separate "Rossville Rural Development" for Negro families on part of the tract adjacent to the white community, but it was never developed. Black families were steered instead to a Public Works Administration low-cost housing project in northeast Washington.

11 Ibid., 37–39.

12 Quoted in Olson, *Baltimore*, 348. Olson cites the population for the greater Baltimore metropolitan area in 1940 as 1.2 million.

13 Argersinger, *Toward a New Deal in Baltimore*, 207.

14 *Maryland, A Guide to the Old Line State*, 89–90. See also the table of automobile ownership and road building in Brugger, *Maryland*, 575, 790.

15 *Maryland, A Guide to the Old Line State*, 307.

16 Many of these shooting scripts can be found under the title "Farm Security Administration / Office of War Information Written Records: Selected Documents" on the Prints and Photographs Division website at www.loc.gov/rr/print/coll/fsawr/fsawr.html.

17 Olson, *Baltimore*, 348–49.

18 Schulz, "Prosperity, Depression, and War, 1917–1945," in Chapelle et al., *Maryland*, 249–50.

19 Olson, *Baltimore*, 304, 348–49, 364–65; Schulz, "Prosperity, Depression, and War, 1917–1945," in Chapelle et al., *Maryland*, 248–51. In May 1943 Roger Smith was sent to the Bethlehem-Fairfield Shipyard specifically to photograph "Negro workers employed in construction of the Liberty Ship SS *Frederick Douglass*;" twenty-three photographs from his assignment are in the FSA/OWI files. General caption for "Lot #988," FSA/OWI microfilm reel 61.

20 Knepper, *Greenbelt, Maryland*, 64–67.

21 Schulz, "Prosperity, Depression, and War, 1917–1945," in Chapelle et al., *Maryland*, 253–54.

Bibliography

Works on FSA and the Photographers

Baldwin, Sidney. *Poverty and Politics: The Rise and Decline of the Farm Security Administration*. Chapel Hill: University of North Carolina Press, 1965.

Bubley, Esther. *The Photographs of Esther Bubley*. Introduction by Melissa Fay Greene. Washington, D.C.: Library of Congress; London: Giles, 2010.

Brannan, Beverly. "Women Photojournalists." an online finding aid prepared for the Library of Congress Prints and Photographs Division, http://www.loc.gov/rr/print/coll/596_womphotoj.html.

Carson, Jeanie Cooper. "Interpreting National Identity in Time of War: Competing Views in United State Office of War Information (OWI) Photography, 1940–1945." Ph.D. diss., Boston University, 1995.

Curtis, James. *Mind's Eye, Mind's Truth: FSA Photography Reconsidered*. Philadelphia: Temple University Press, 1989).

Delano, Jack. *Puerto Rico Mio*. Washington, D.C.: Smithsonian Institution Press, 1990.

———. *The Photographs of Jack Delano*. Introduction by Esmeralda Santiago. Washington, D.C.: Library of Congress; London: Giles, 2010.

Doty, C. Stewart, Dale Sperry Mudge, Herbert John Benally, with photographs by John Collier, Jr., *Photographing Navajos: John Collier, Jr. on the Reservation, 1948–1953*. Albuquerque: University of New Mexico Press, 2002.

Doty, Robert, ed. *Photography in America*. New York: Whitney Museum of Art, 1974.

Doud, Richard. Interview with Edwin and Louise Rosskam, conducted August 3, 1965. Smithsonian Institution, Archives of American Art, transcript available at www.aaa.si.edu/collections/interviews.

———. Interviews with Roy Stryker, conducted October 17, 1963, June 13, 1964, and January 23, 1965. Smithsonian Institution, Archives of American Art, transcript available at www.aaa.si.edu/collections/interviews.

Fisher, Andrea. *Let Us Now Praise Famous Women: Women Photographers for the U.S. Government, 1935 to 1944: Esther Bubley, Marjory Collins, Pauline Ehrlich, Dorothea Lange, Martha McMillan Roberts, Marion Post Wolcott, Ann Rosener, Louise Rosskam*. New York: Pandora Press, 1987.

Fleischhauer, Carl, and Beverly W. Brannan, eds. *Documenting America, 1935–1943*. Berkeley: University of California Press in Association with the Library of Congress, 1988.

Gidley, G. M. "John Collier Jr." in Martin Marix Evans, ed., *Contemporary Photographers*, 3rd ed. New York: St. James Press, 1995.

Guimond, James. *American Photography and the American Dream*. Chapel Hill: University of North Carolina Press, 1991.

Hurley, F. Jack. *Marion Post Wolcott: A Photographic Journey*. Albuquerque: University of New Mexico Press, 1989.

————. *Portrait of a Decade: Roy Stryker and the Development of Documentary Photography in the Thirties*. Baton Rouge: Louisiana State University Press, 1972.

————. *Russell Lee, Photographer*. Dobbs Ferry, NY: Morgan and Morgan, 1978.

Jones, William E. *Killed: Rejected Images of the Farm Security Administration*. New York: PPP Editions, 2010.

Keller, Ulrich. *The Highway as Habitat: A Roy Stryker Documentation, 1943–1955*. Santa Barbara, CA: University Art Museum, 1986.

Lee, Russell. *The Photographs of Russell Lee*. Introduction by Nicholas Lemann. Washington, D.C.: Library of Congress in association with Giles, 2008.

Mora, Gilles, and Beverly W. Brannan. *FSA: The American Vision*. New York: Abrams, 2006.

Mydans, Carl. *Carl Mydans: Photojournalist*. New York: Abrams, 1985.

Mydans, Carl. *The Photographs of Carl Mydans*. Introduction by Annie Proulx. Washington, D.C.: Library of Congress, 2011.

O'Neal, Hank. *A Vision Shared: A Classic Portrait of America and Its People, 1935–1943*. New York: St. Martin's Press, 1976.

Plattner, Steven W. *Roy Stryker, U.S.A., 1943–1950: The Standard Oil (New Jersey) Photographic Project*. Austin: University of Texas Press, 1983.

Pratt, Davis, ed. *The Photographic Eye of Ben Shahn*. Cambridge: Harvard University Press, 1975.

Raeburn, John. *Ben Shahn's American Scene: Photographs, 1938*. Urbana: University of Illinois Press, 2010.

Rothstein, Arthur. *The Photographs of Arthur Rothstein*. Introduction by George Packer. Washington, D.C.: Library of Congress, 2011.

Schulz, Constance B. *A South Carolina Album, 1936–1948*. Columbia: University of South Carolina Press, 1992.

————. *Bust to Boom: Documentary Photographs of Kansas, 1936–1949*. Lawrence: University Press of Kansas, 1996.

————. *Michigan Remembered: Photographs from the Farm Security Administration and the Office of War Information, 1936–1943*. Detroit, MI: Wayne State University Press, 2001).

Schulz, Constance B., and Steve Plattner. *Witness to the Fifties: The Pittsburgh Photographic Library, 1950–1953*. Pittsburgh: University of Pittsburgh Press, 1999.

Stange, Maren. *Symbols of Ideal Life: Social Documentary Photography*. New York: Cambridge University Press, 1988.

Stott, William. *Documentary Expression and Thirties America*. New York: Oxford University Press, 1973.

Stryker, Roy E., and Nancy Wood. *In This Proud Land: America, 1935–1943, as Seen in the FSA Photographs*. Greenwich, CT: New York Graphic Society, 1973.

Trachtenberg, Alan. *Reading American Photographs: Images as History, Mathew Brady to Walker Evans*. New York: Hill and Wang, 1989.

Vachon, John. *John Vachon's America: Photographs and Letters from the Depression to World War II,* ed. Miles Orvell. Berkeley: University of California Press, 2003.

Viskochil, Larry. "Arthur Siegel," in Marrin Marix Evans, ed., *Contemporary Photographers,* 3rd ed. New York: St. James Press, 1995, 1025–26.

Weiglie, Marta, ed. *Women of New Mexico.* Santa Fe, NM: Ancient City Press, 1993.

Wolcott, Marion Post. *The Photographs of Marion Post Wolcott*. Introduction by Francine Prose. Washington, D.C.: Library of Congress, 2008.

Works on Maryland

Argersinger, Jo Ann E. *Toward a New Deal in Baltimore: People and Government in the Great Depression*. Chapel Hill: University of North Carolina Press, 1988.

Brugger, Robert J. *Maryland: A Middle Temperament, 1634–1980*. Baltimore: Johns Hopkins University Press, 1988.

Chapelle, Suzanne Ellery Green, Jean H. Baker, Dean R. Esslinger, Whitman H. Ridgway, Constance B. Schulz, and Gregory A. Stiverson. *Maryland: A History of Its People*. Baltimore: Johns Hopkins University Press, 1986; second edition forthcoming.

Knepper, Cathy D. *Greenbelt, Maryland: A Living Legacy of the New Deal*. Baltimore: Johns Hopkins University Press, 2001.

McDaniel, George. *Hearth and Home: Preserving a People's Culture*. Philadelphia: Temple University Press, 1982.

McWilliams, Jane Wilson. *Annapolis, City on the Severn: A History*. Baltimore: Johns Hopkins University Press, 2011.

Olson, Sherry H. *Baltimore: The Building of an American City*. Baltimore: Johns Hopkins University Press, 1980.

Schulz, Constance B. "Prosperity, Depression, and War, 1917–1945," in Suzanne Ellery Green Chapelle et al., *Maryland: A History of Its People*. Baltimore: Johns Hopkins University Press, 1986.

Walsh, Richard, and William Lloyd Fox, eds. *Maryland, a History, 1632–1974*. Baltimore: Maryland Historical Society, 1974.

Warren, Mame, and Marion E. Warren. *Maryland Time Exposures, 1840–1940*. Baltimore: Johns Hopkins University Press, 1984.

Wennerstein, John. *Maryland's Eastern Shore*. Centreville, MD: Tidewater Publishers, 1992.

Writers' Program of the Work Projects Administration in the State of Maryland. *Maryland: A Guide to the Old Line State*. New York: Oxford University Press, 1940. Reissued as *Maryland: A New Guide to the Old Line State*, edited by Earl Arnett, Robert J. Brugger, and Edward C. Papenfuse. Baltimore: Johns Hopkins University Press, 1999. (Quotes in the text are to the 1940 edition.)

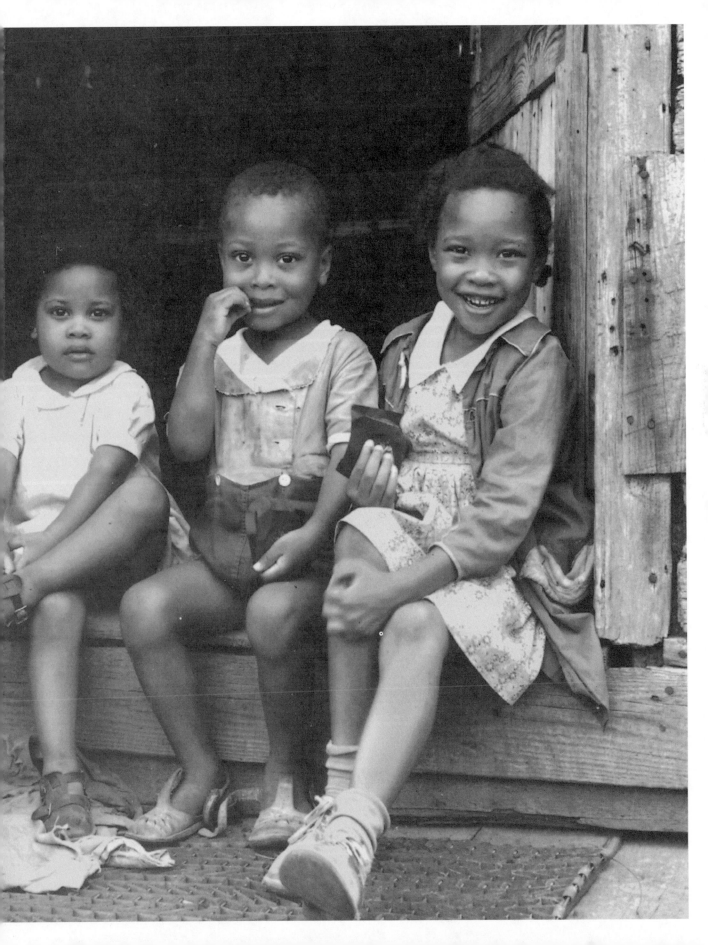

Index

Italic page numbers refer to photographs or their captions; boldface page numbers refer to biographical sketches of the photographers.

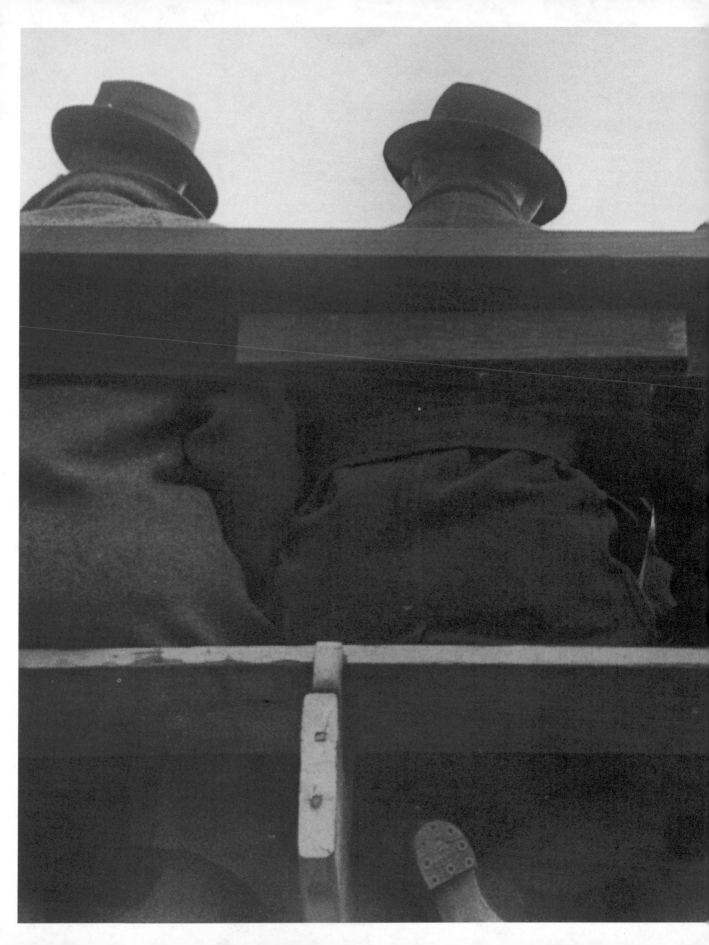